SECRET
WARRINGTON

Janice Hayes & Philip Jeffs

AMBERLEY

First published 2023

Amberley Publishing
The Hill, Stroud
Gloucestershire, GL5 4EP

www.amberley-books.com

ISBN 978 1 3981 0816 5 (print)
ISBN 978 1 3981 0817 2 (ebook)

British Library Cataloguing in Publication Data.
A catalogue record for this book is available from the
British Library.

Origination by Amberley Publishing.
Printed in Great Britain.

Contents

Introduction

Warrington is a twentieth-century New Town with a history stretching back to prehistoric times. During the last half century, its population has effectively trebled in size while the town has been transformed from a Lancashire town of heavy industry to a Cheshire business centre.

The geography of Warrington also changed with local government reform in 1974, which brought parts of old Lancashire and Cheshire within the borough boundaries. Some traditional villages like Grappenhall, Thelwall and Appleton outwardly retain their rural character, while new districts at Padgate, Birchwood, Westbrook, Chapelford and Omega emerged from previously derelict areas of Second World War installations. Old industrial sites have given way to business parks, logistics hubs, retail centres and housing estates, while the town centre has been in continuous evolution with its townscape changing at almost bewildering speed.

Warrington's older residents have fading memories of the town of their youth, while to younger generations and incomers from other areas of the United Kingdom and the wider world the town's history seems hidden from sight. Warrington's past seems a secret known only to local historians and archaeologists and is no longer passed down through the generations through oral tradition.

Some sectors of the town's population seem neglected in official accounts. Ordinary working-class Warringtonians, the poor, those with disabilities or hidden away in institutions like the workhouse or county asylum were apparently not deemed worthy of personal histories, while women were merely second-class citizens in a masculine world. Meanwhile, the powerful men who shaped the town's story seemed able to control their own place in history. To modern eyes, these former pillars of local society seem to have a veneer of respectability which hides the darker secrets of their wealth and avoids the taint of scandal. For some, like the LGBTQ community, secrecy was safety as they were deemed lawbreakers, while others found refuge in groups with their common identity obscured from outsiders.

Secret Warrington aims to reveal some of these fascinating hidden stories. More of the town's history can be unlocked by visiting the collections held at Warrington Museum and its archives section, which is also striving to fill gaps in the official records. However, until the massive task of digitising all the objects, photographs, volumes of documents and official records is completed, some stories of Warrington's past may yet remain hidden from citizens of the present and future digital age.

1. Lost Landscapes and Hidden Landmarks

Warrington's location on a natural crossing point over the river which has flown through the area since prehistoric times has helped shaped its landscape and history. Today the river meanders almost invisibly through parts of the town and often even the name of the Mersey is forgotten.

Derived from Old English for 'boundary river', the Mersey has marked the boundaries of old kingdoms and historic counties with treacherous marshes to the north and west of Warrington, a high sandstone ridge to the south, and strong currents near its mouth to the sea. At Warrington, however, the river could be forded and later bridged, making it an important node on the local and national transport network and an ideal site for settlement. The river has changed its course through the town over the centuries and broken into smaller brooks which became the boundaries of the town's separate communities.

Although apparently lost in time, the traces of the town's earliest residents have been uncovered by archaeologists and displayed in the town's museum. Stone Age tools have been found in present-day areas including Orford, Stockton Heath and Birchwood but the first settlers can be traced back almost 5,000 years to the Bronze Age round barrows discovered around Grappenhall, Croft, Risley, and especially the Winwick area. At Highfield Lane, the raised mound of its burial barrow can still be detected,

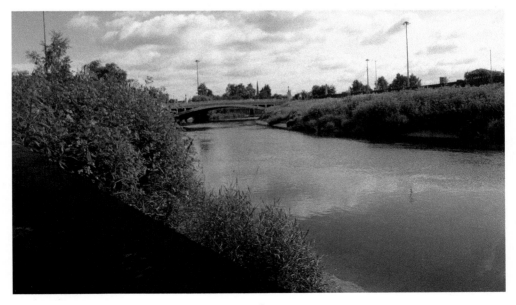

Nature reclaims the banks of the Mersey near Bridge Foot.

The Highfield Lane barrow partially hides the white two-storey house.

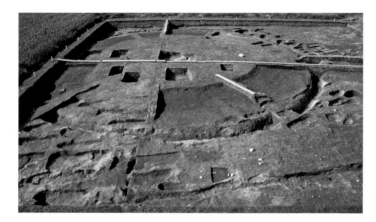

Excavations at the Southworth Hall barrow.

although centuries of ploughing have reduced its height. Excavation of the barrow near Southworth Hall in 1980 revealed not only burial urns and offering cups from cremation burials but also much later Christian graves. Soil and pollen analysis even revealed the crops grown nearby.

Archaeologists have also revealed Warrington's first major settlement at Wilderspool, the first industrial centre in the history of north-west England. Almost 2,000 years ago, it emerged as an important Roman settlement, a town with a large riverside manufacturing and warehousing zone, with potteries, iron and lead workshops. Pottery from Wilderspool has been found as far afield as Hadrian's Wall and potters' kilns were excavated near St Thomas's Church, while modern maps still list Roman Road at Stockton Heath. By around AD 350 Wilderspool, like the Roman empire itself, declined and the north bank of the river rather than Wilderspool became the heart of the emerging modern town.

The town's place names give many clues to its past. In 1086, the Domesday Book compiled for England's new Norman king, William I, lists the town as *Walintune*, with a small community, probably near to the site of the ford at *Howley* (a hollow meadow) and across from the other side of the ford at *Latchford* (a ford over a lake or stream). William

rewarded many of his followers with land and subsequently Paganus de Vilars sublet the manor of Warrington. His daughter married Richard Pincerna, who held the honorary post of butler to the Earl of Chester, and subsequent generations adopted the name of Boteler (Butler). Later, the de Vilars coat of arms of red lions and the Botelers' six gold cups on a blue background would feature on Warrington's coat of arms and can still be found around the town hall gates today.

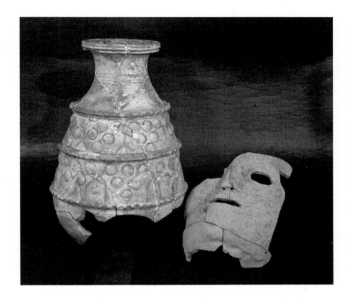

Right: Pottery from Roman Wilderspool on show at Warrington Museum.

Below: Hall's map of 1826 shows Warrington's medieval village.

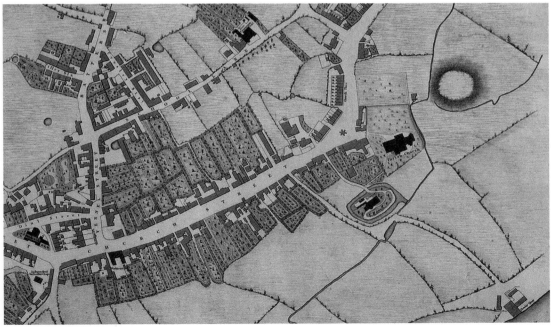

The Botelers chose a raised site at Howley to build a simple wooden castle, overlooking the ford and near the existing Saxon village and church. The medieval village of Howley, which grew around the castle and surrounded by open fields, is still visible on Hall's 1826 map. The remains of the circular mound of the castle stand next to the parish church and its moated rectory and the route to the old ford (Howley Lane). The wide main street, site of weekly markets and annual fairs, is lined with long narrow plots of medieval cottages and gardens and the back lane leads to the grammar school. In the late thirteenth century, the Botelers chose to move to a more desirable country property, their hunting lodge at *Beau see* (the 'beautiful place') whose name was eventually modified to Bewsey.

The spire of Warrington's parish church remains the most visible feature of Warrington's skyline, dominating the surrounding landscape, but today the building is tucked away on the fringe of the town centre. Although a church dedicated to St Elphin is recorded in the Domesday Book, there had probably been a place of worship there since the seventh century. The parish was the centre of local government and church festivals were an important part of people's lives.

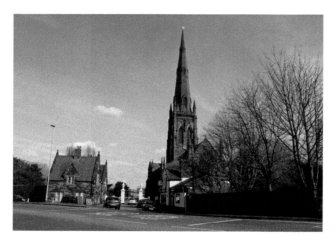

Warrington parish church and its distinctive spire.

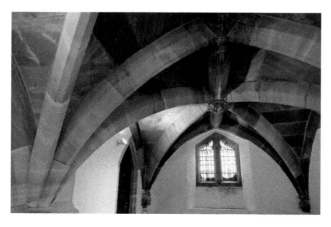

The fourteenth-century crypt under the parish church.

In the early twelfth century, the church was rebuilt in stone and remodelled in the fourteenth century as the town grew in prosperity. The crypt of this building and its staircase, the main chancel and parts of the transept survived the drastic Victorian remodelling by Revd William Quekett who became Rector of Warrington in 1854. He made it his mission to improve the church but today the parish church interior still enshrines much of Warrington's history through its memorials and stained-glass windows.

DID YOU KNOW
Warrington has the third highest parish church spire in England, with a height of around 281 feet (85.65 metres).

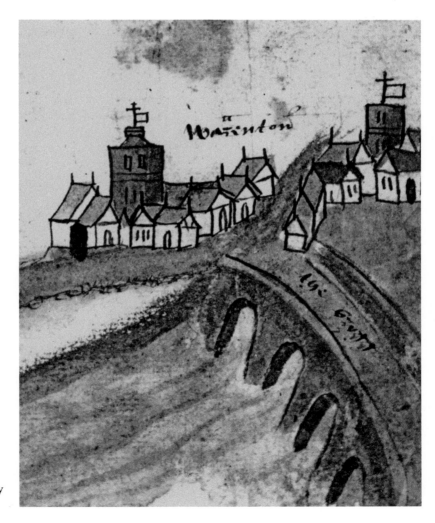

Warrington in the 1580s with the Friary (left).

The parish church with its original tower can be seen on the right of the earliest contemporary image of the town, dating back to the 1580s. By then, the town centre had moved away from Church Street to a new street leading from the bridge, which the Botelers had built to replace the ancient ford. Another church on the left of the street towers above the half-timbered houses along present-day Bridge Street.

Today only the nearby street names of Friar's Gate and St Austin's Lane give clues to the site of Warrington Friary, home of the Austin friars of the Order of Saint Augustine. The Botelers and other wealthy landowners had given land and financial support to the friars, who were well respected in the town for their charitable work and ministry. However, when King Henry VIII broke away from the Roman Catholic Church the monasteries were dissolved and the friary and its lands were sold off. Much of its stonework was removed and reused but successive archaeological excavations from the late 1880s have revealed its substantial foundations and surrounding graveyard.

Warrington's parish church was destined to play an important part in the English Civil War that broke out between King Charles I and Parliament in September 1642. Because of its location at the lowest bridging point on the Mersey, control of Warrington was vital to both sides. The Earl of Derby set up his headquarters in Church Street to hold Warrington for the king, but at Easter 1643 Parliamentary forces attacked Warrington from all directions. The church was used as a Royalist stronghold, while Parliamentary cannon bombarded the town from Mote Hill just to the east and their cannonball marks can still be seen on the exterior of the chancel. Derby retreated having set the town centre on fire as a last desperate strategy and the town eventually fell to Parliamentary troops.

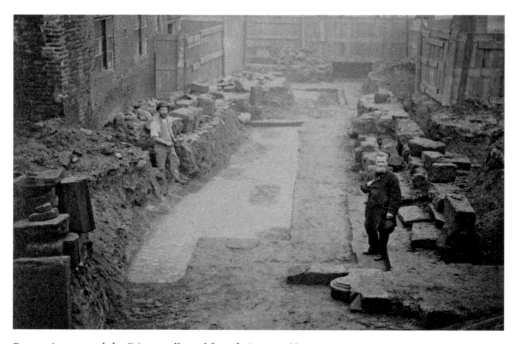

Excavations reveal the Friary walls and foundations c. 1887.

Right: Cannonball marks on the chancel wall of the parish church.

Below: Cromwell's lodgings (centre) with the Tudor Cottage (right).

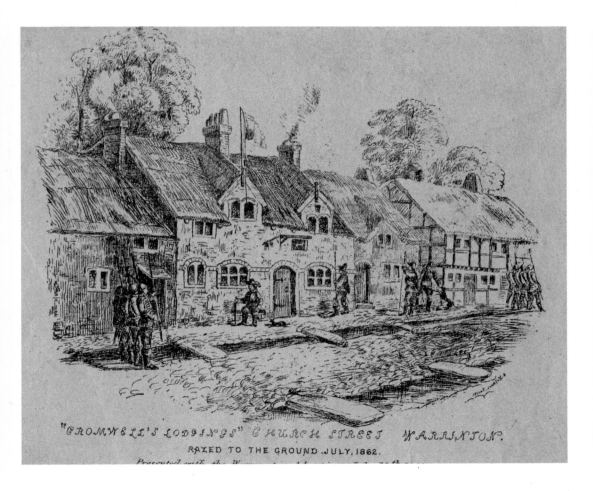

"CROMWELL'S LODGINGS" CHURCH STREET WARRINGTON.
RAZED TO THE GROUND JULY, 1862.

Oliver Cromwell spent the night in a cottage on Church Street during the later battles of 1648. He led the Parliamentary army which was trying to stop Charles I regaining the throne with Scottish support. On 19 August, the two armies clashed at the Battle of Red Bank near Winwick. The Scots retreated to Warrington where they lost a skirmish with Cromwell's troops at Warrington Bridge and Cromwell lodged in the town at a long-demolished building to the left of the so-called Tudor Cottage. To commemorate Cromwell's links to the town and the 300th anniversary of his birth in 1899, Councillor Frederick Monks presented to the town the statue of Cromwell which now stands near to Warrington Bridge.

Few of the town's medieval buildings survived the Civil War and more recent twentieth-century housing and urban development which steadily expanded across Warrington's farmland. However, Barrow Old Hall, first recorded in 1313, is a partial survivor of this period, remaining as a moated site in the angle between Billington Close and Barrow Hall Lane, next to the Great Sankey High School. The hall fell into disrepair and was demolished in the early 1920s, but the moat was cleaned and restored.

By the eighteenth century, major improvements to water transport had enhanced Warrington's importance. In the late 1690s, the Mersey was deepened and made navigable from Runcorn to Bank Quay by the Patten family. In the 1720s, the Mersey–Irwell Navigation Company made the river navigable for flat-bottomed barges and

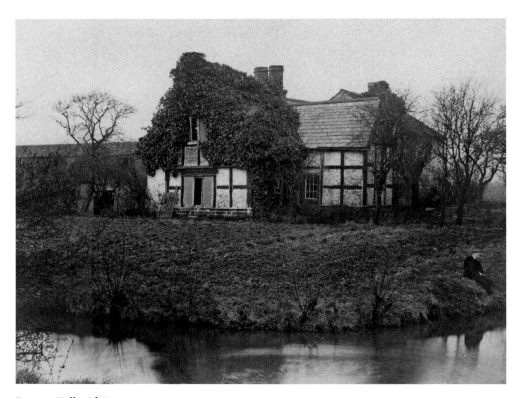

Barrow Hall with its moat *c.* 1900.

small barges, linking Liverpool to Manchester via Warrington. Baines Directory of 1825 recorded that:

> The communication between Manchester and Liverpool, by means of this navigation is incessant, and the brick dust coloured sails of the barges are seen every hour of the day on their passage, flickering on the wind.

Many of these sails may have been manufactured in Warrington; possibly half the cloth for Nelson's naval battles against France's Napoleonic Empire was woven in the town. While sail cloth manufacture declined in importance in the nineteenth century Warrington's maritime connections continued. Clare & Ridgway introduced shipbuilding at their Sankey Bridges yard in the early 1900s, while Richie and Black introduced the unlikely concept of building concrete boats at Fiddler's Ferry. However, the vessels could not only float but the company claimed they would be ideal for tropical climates, have a larger cargo capacity, and were cheaper to produce than conventional boats. Concrete Seacraft's first concrete barge, the *Elmarine*, launched in January 1919, was the first concrete vessel to be listed by Lloyd's of London.

DID YOU KNOW
Warrington once had a thriving fishing trade. Sturgeon, greenbacks, mullets, seals, sand eels, lobsters, prawns, and the best and largest cockles in all England were still caught in the Mersey until the late eighteenth century, before the river became polluted with industrial waste.

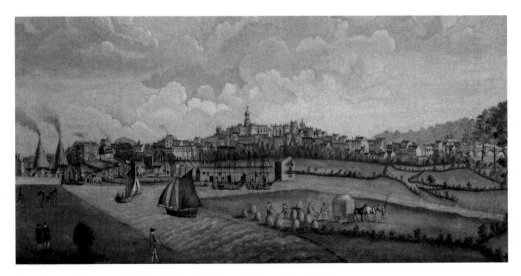

Warrington in 1772, with the bridge (right) and Bank Quay (left).

A concrete boat at Fiddler's Ferry.

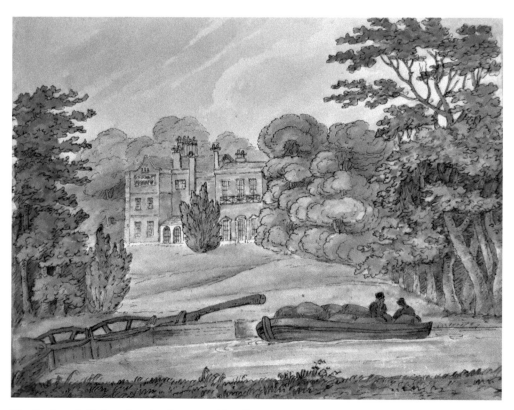

The Sankey–St Helens Canal at Bewsey Old Hall, 1830s.

In the early eighteenth century, the Mersey and Irwell Navigation was created by linking the two rivers, dramatically enhancing Warrington's role as a transport hub. Raw materials could be imported from further afield, including copper and lead ores from North Wales or exotic cargoes of palm oil and olive oil destined for the new soap and chemical industries. One important change to the landscape of the area was the construction, of Britain's first true canal, the Sankey–St Helens Canal, in 1757–59. The canal, passing just beyond the wooded surrounds of Bewsey Hall, remains one of the most important historical features in the region.

By the mid-eighteenth century, Warrington's location on the national road network ensured that sixty to seventy stagecoaches ran daily through its main streets. A network of coaching inns sprang up on Sankey Street and Bridge Street, which was a narrow bending highway bustling with traffic, and the arrival of a stagecoach led to scenes of frantic activity. Special curved blocks were built into the base of the Lion Hotel's entrance to ensure the coaches did not collide with the inn's walls and these can still be seen today as a hidden reminder of Warrington's coaching age.

By the late 1830s, the railway age had arrived at Bank Quay station, and by the 1870s, Warrington's links with the national railway network helped it develop as a major industrial centre offering a variety of employment.

Curved blocks protect the Lion Hotel's entrance from coach wheels.

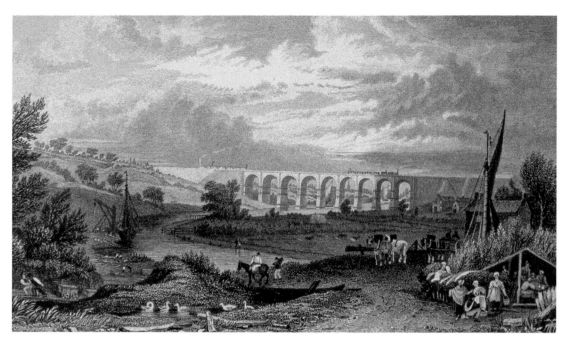

The impressive railway viaduct over the Sankey Canal at Newton.

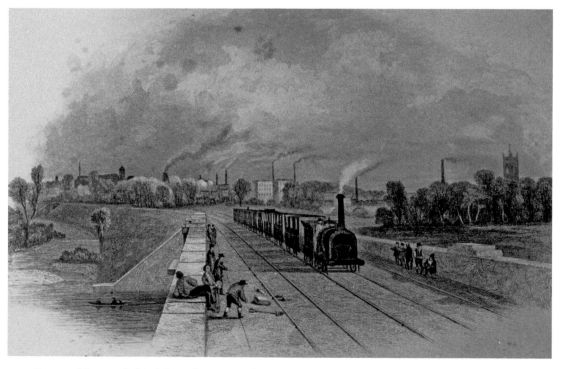

Factory chimneys behind the railway at Bank Quay, 1830s.

When Charles Dickens published his novel *Hard Times* in 1854 he was reflecting on the hardships of the working class as they were forced to abandon rural life and crowd into the new industrial centres. Warrington census returns from 1841 reveal the thousands of new families who settled in the town but many more passed through on the tramp for work. These weary travellers had to rest in hedgerows, while desperately seeking water to quench their thirst.

In 1859, local doctor James Kendrick recommended the introduction of:

Substantial stone seats or Travellers' Rests, at the sides of highways much frequented by pedestrians... The high road from Liverpool to Manchester is a thoroughfare of this description, more especially for the immigrant Irish labourers required in agricultural district s... (I suggest) ... a low seat, to allow of the body bending forwards, with the elbows resting on the knees. I have been led to fix upon sixteen inches as the best elevation... At each end of the centre seat is one of ten inches high for the children, which likewise forms a convenient footstool for a mother with an infant on her lap.

Several Travellers' Rests were installed across the town from Winwick to Grappenhall, all sponsored by local donors and often accompanied by public drinking fountains. Eventually the Travellers' Rests fell out of use and surviving remnants have been mistaken for mounting blocks, removing their link to an important period of Warrington's social history.

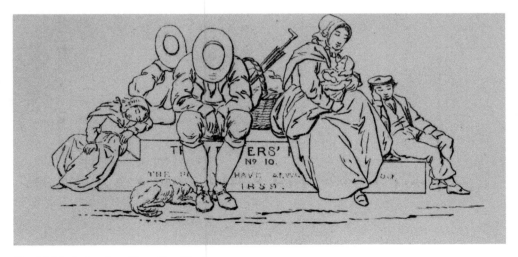

Kendrick's design for a Travellers' Rest.

A child sits on the Winwick Travellers' Rest *c.* 1890s.

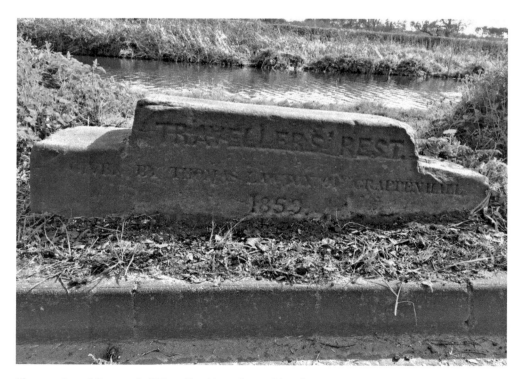

The remains of Grappenhall Travellers' Rest donated by Thomas Lawton in 1859.

Another remnant of Victorian Warrington lies forgotten at Bridge Foot despite the thousands that pass by daily. A capstone from the old Victoria Bridge of 1836–1913 stands alongside the older of the two bridges that now cross the Mersey. Whilst travellers over Warrington Bridge usually see it as a traffic bottleneck, from the riverbank the sleek lines of one of the country's earliest reinforced concrete bridges can be admired. Its architect was Warrington-born John James Webster who had also designed the old Widnes–Runcorn Bridge and piers from Dover to Llandudno.

Commemorative plaques on the bridge and other monuments across the town provide clues to the town's forgotten past and key figures that have helped shaped Warrington's history.

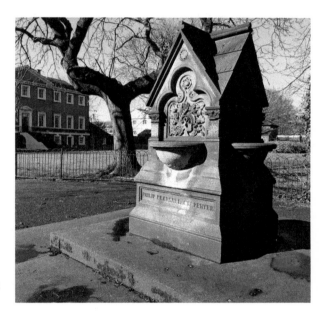

The last surviving drinking fountain in the town hall grounds.

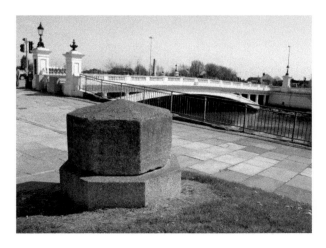

The capstone of the old Victoria Bridge at Bridge Foot.

2. Local Legends and Villainous Characters

Although much of Warrington's history can be verified by written records or physical remains, stories passed on by oral tradition also offer clues to the past. These legends often had a basis in truth but have been dramatised over time and others are merely urban myths ... rumours which have been accepted as fact.

One local legend tells how the powerful Bold family of the west Warrington area came to have their title and lands. Once upon a time the villagers of Cuerdley marshes were terrorised by a griffin, a mythical beast with the body of a lion but the head and wings of an eagle. They watched helplessly as the creature swooped down from its rocky lair to carry away their cattle. When the prize ox of local blacksmith Robert Brych was stolen an epic contest brought the griffin's reign of terror to an end. Robert made an iron cage, covered it with cowhide and hid inside clutching a sharp sword. Starved of other prey, the griffin hoisted the cage aloft and struggled back to its lair where it was mortally wounded by Robert who carried its severed head back to the village in triumph. News of his exploits reached the king, who gave him lands and the title of Robert the Bold. The griffin featured proudly on the Bold coat of arms as a symbolic reminder of their might.

A griffin at rest after devouring its kill.

Centuries later the story of Jenny Greenteeth also became part of local oral tradition. In 1870, the author, poet and travel writer William Davies of Warrington wrote in a local newspaper the earliest account of the evil spirit known to generations of Warrington children as Jenny (or Jinny) Greenteeth.

Davies writes that in the early 1800s, there were several pits and ponds around Warrington reputed to be the home of Jenny Greenteeth, but by the time of his writing he knew of only one: Pemberton's Pit in Latchford. Jenny Greenteeth was said to be an evil spirit lurking beneath the water in pits, ponds and canals. You could tell her hidden presence by her weed-like hair floating on the surface of the water. If a child wandered too close to the water's edge, Jenny was said to drag them under with her long sinewy arms, drown them and then eat them up. Warrington mothers passed down the story as a useful means of stopping their children from playing by dangerous waters.

Several Warrington legends are associated with particular areas of the modern town. St Oswald's Church at Winwick is now at the northern edge of Warrington but for most of its history has been outside the old borough of Warrington. The Winwick area has settlements dating back to the Bronze Age period and the raised platform on which the church sits would have been an ideal position to keep watch over the surrounding landscape and the nearby Roman road. Tradition associates nearby Ashton-in Makerfield with the site of the death of Oswald, Christian King of Northumbria in AD 642 at the Battle of Maserfield, and the church is dedicated to this saint. It is likely that there was a pre-Christian sacred place nearby and it was common for Christian churches to adopt an earlier holy site.

Winwick Church sits on a raised platform.

The Winwick pig (right) on the church wall.

According to an ancient story, the exact spot where the church was to be built was decided by a pig. As the foundation stones of an earlier church were laid it was seen running around the building site, shrieking 'Wee-ick, Wee-ick'. The pig was said to have picked up a stone in its mouth and dropped it on the spot where the saintly king had fallen. The builders took this as a sign and abandoned the original site in favour of the place where the stone had dropped. In fact, the name Winwick was not given to us by a pig, but means 'the dairy farm belonging to Wineca'.

Thelwall's village pub reflects the history of its village. The Pickering Arms recalls the family who became the major landowners in 1662, but an inscription on the gable end of the half-timbered building recalls an earlier history, proclaiming, 'In the year 923 King Edward the Elder founded a city here and called it Thelwall.' But was there really a city there?

By the early tenth century, Thelwall lay in a war zone between the Viking kingdom of Northumbria to the north and the English kingdom of Mercia to the south, which was ruled by Aethelflead, a daughter of Alfred the Great. She and her brother, the English king Edward the Elder (who reigned from AD 899–925), oversaw the construction of a series of fortified frontier outposts, known as *burhs*, to act as the front line against attack from the north. The Thelwall burh was built to defend the vital strategic crossing point on the Mersey, certainly by AD 923, but possibly as early as AD 919.

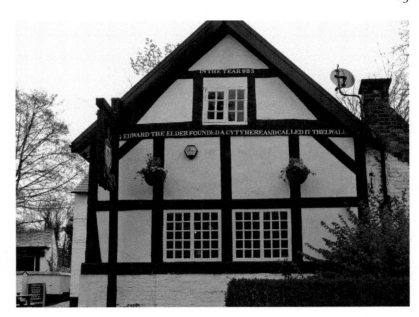

The inscription about the Thelwall city on the Pickering Arms.

Its exact location is now uncertain, as the shifting course of the river has eroded the site and washed away all traces. Its most likely location was somewhere close to Thelwall Eyes, the great flat marshy former island which lies immediately across the Ship Canal from the centre of the modern village. The small burh at Thelwall did not develop into a city because of the growing importance of Warrington, which lay on a more important river crossing point.

Near to Thelwall lies the village of Grappenhall with St Wilfrid's Church at its heart. Grappenhall is mentioned in the Domesday Book of 1086, and the church probably dates from the twelfth century. However, it has a more recent claim to fame as it is widely accepted that a stone carving on the tower might have inspired Lewis Carroll's 'Cheshire Cat' as his father, the Revd Dodgson, often visited the church.

However, perhaps one of Bewsey's best-kept secrets is that it may have been the inspiration for another of Lewis Carroll's most beloved characters: the White Rabbit. *Alice's Adventures in Wonderland* began when she chased a white rabbit down the passages of a rabbit hole. Did Carroll base this story on the *Ghostly White Rabbit of Bewsey*?

Around 1840, a local historian James Kendrick wrote about:

a beautiful white rabbit which for time immemorial has visited the possessor of Bewsey and as surely as its appearance has been followed by death or misfortune ... this timid wanderer ... has been known to vanish ... leaving its pursuers to grasp the empty air.

What's the connection with Lewis Carroll? His father, Charles Dodgson, was the vicar of Daresbury and a family friend was T. V. Bayne, the headmaster of the Boteler Grammar School. Bayne knew Kendrick and also the Revd Horace Powys, who was the brother of Lord Lilford, the owner of Bewsey Old Hall. Perhaps Bayne told the story of the white rabbit to his young godson, the future Lewis Carroll.

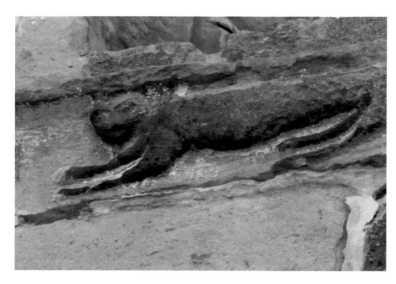

The sinister carved stone cat on Grappenhall Church.

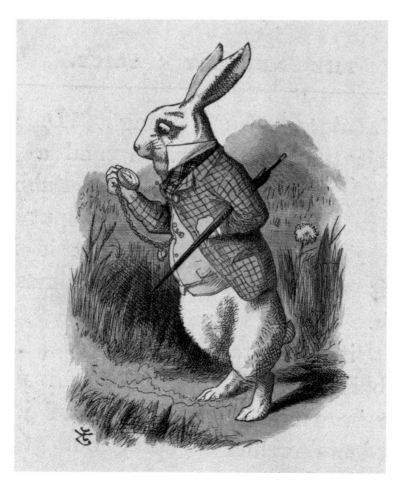

Lewis Carroll's White Rabbit, perhaps inspired by a Bewsey Legend?

Bewsey Old Hall hides its secrets.

It is hardly surprising that a house as old as Bewsey Hall features in other legends and has its very own ghost. A number of Bewsey residents recalled the story of the 'White Lady' who haunted the grounds. A statue of the White Lady in the maze of Bewsey Old Hall is based on the story of Lady Isabella Boteler, widow of Sir John Boteler, who had died in 1430 at the age of twenty-eight, leaving only a son, aged one, to succeed him and three young daughters. As a wealthy widow Isabella was a target for fortune hunters and five years after her husband's death William Pulle, with a gang of men, broke into the house and carried her off on horseback. He forced her to marry him at Bidston Church before taking her into hiding in Wales. She was eventually found and rescued but he escaped. Lady Isabella declared him an outlaw and petitioned Parliament to have him arrested and tried, and was granted that right but he evaded capture and trial. The abduction and death of her father, Sir William Haryngton, seemed too much for her spirit and she died in 1441. Her ghost may still haunt the grounds but her family name lives on in Haryngton Avenue.

No trace of a legendary figure remains at Culcheth ... the notorious Colonel Blood who stole the crown jewels! In 1650, Thomas Blood had married Maria, eldest daughter of Colonel John Holcroft, a major Culcheth landowner and leading local supporter of Parliament in the civil war against King Charles I. In 1648, Cromwell's Parliamentary troops, including the dashing young Irish Lieutenant Blood, were pursuing the remnants of a Royalist army at Winwick. Blood met Holcroft, who later rued the day he invited the young Irishman back to Holcroft Hall where he captivated the eldest daughter, Maria. Despite parental disapproval Maria and Blood were married at the parish church of Newchurch on 21 June 1650.

When Charles II was returned to the throne in 1660, Blood lost his lands in Ireland and was dismissed from the army. Leaving his wife and two children at Holcroft Blood, he went off to seek revenge against the king. An unsuccessful attempt to capture Dublin Castle led him to flee to Holland, Scotland, and eventually London, where he became a spy for the Duke of Buckingham, one of the king's advisors. By 1670, Blood was an outlaw with a royal reward offered for his capture after a series of daring escapades. Rather than going into hiding he launched his most audacious plan of all: to breach the security of the Tower of London, seize the crown jewels and hold them to ransom. A first attempt with Maria as a decoy failed, so he returned with son Thomas and other accomplices. This time they succeeded in making off with the jewels, but were swiftly caught and Blood was found to have the royal crown under his cloak. Against all the odds Blood escaped the king's wrath, thanks to Buckingham, his powerful ally at court. He was not only pardoned for his crime but had his Irish estates returned with a pension too and became a folk hero.

The tale of the Woolston Highwayman may have echoes of the legendary Dick Turpin but most highwaymen were nothing more than common criminals with scant regard for human life. In the early hours of Thursday 15 September 1791, twenty-four-year-old post office employee James Hogwarth rode out of Warrington towards Woolston carrying mail and money bound for Manchester.

Near Bruche Bridge he was ambushed by an armed gang who tied him up, stole his mail bags, beat him around the head, cut his throat and left him to drown in the brook. Warrington was horrified by the crime, not least because Hogwarth's widow was heavily pregnant. The Post Office offered a substantial reward of £200 for the robbery to prevent similar crimes.

There were two chief suspects: Thomas Fleming and Edward Miles, who 'was morally certain to be one of the Mail Robbers'. Both men were linked to passing banknotes known to have been in Hogwarth's mail bag and also being part of a gang counterfeiting money. Fleming was captured first but sentenced to death for a different highway robbery.

Miles escaped capture until 1793, when he was put on trial at Lancaster Castle and found guilty of the charge of the Woolston robbery but not of murder. Much of the evidence against him was circumstantial but his counterfeiting activities alone made him a villain who deserved the death penalty. The judge ordered that an example should be made of Miles, the ringleader. He was hanged at Lancaster and his body preserved in a coating of tar. This was taken back to the scene of the crime and encased in a metal skeleton suspended from a wooden gibbet post to warn future attackers of postboys of the fate that would await them. In reality Hogwarth's colleagues were probably more scared by the experience of riding down Manchester Road on a dark and stormy night and hearing the ghostly figure in the gibbet irons creaking in the wind.

Surprisingly the most vivid reports of a ghostly apparition around the town only occurred in 1927 with the alleged arrival of 'Spring Heeled Jack'. The first sightings of this creature had occurred in London in the 1830s. Descriptions of him varied; some people described him as wrapped in white oilcloth with a mask or helmet over his face with glowing eyes, while others described him as wrapped in a black cloak with an evil, devil-like appearance.

Mail Robbery
AND
MURDER.

ON THURSDAY the 15th of September, 1791, about Five o'Clock in the Morning, the POST BOY carrying the MAIL (on Horseback) from *WARRINGTON* to MANCHESTER, was murdered about a Mile from *Warrington*, the Mail opened, and the Letters in the following Bags taken out and carried away, viz. the *Chefter Bags* for *Manchefter* and *Rochdale*, and the *Liverpool* and *Warrington Bags* for *Rochdale*.

EDWARD MILES is a native of Garfton, near Liverpool, about thirty-five years of age, about five feet six inches high, rather flender, thin vifaged, of a pale complexion, very little (if any thing) marked with the fmall-pox; has brown hair, fhort and lank, but is entirely bald on the crown of his head; he is fuppofed to wear a blue coat, with metal buttons, a chocolate and yellow velveret waiftcoat, dark velveret breeches, a drab great-coat, narrow brim'd low crown'd hat, and no boots.

He fome time fince kept the Red Lion public-houfe, in Garfton; afterwards refided in Liverpool, near St. James' Church, but for more than twelve months paft has lived near Knot Mill, in Manchefter, and kept a cart and team for hire. He has a mother and fifter living at the top of Norfolk-ftreet, Parklane, Liverpool.

☞ This man it is morally certain is one of the Mail Robbers. He was in Warrington yefterday at noon.

GEORGE MILES is about forty-two years of age, (brother of the above) about five feet nine inches high, a lufty man, but not corpulent, of a frefh complexion, fandy hair, bald in the front, and has loft two fore teeth in his lower jaw. He is fuppofed to wear a blue coat, black waiftcoat, and dark fuftian breeches.

He lived in Allerton, on a farm held under Meffrs. Clegg and Pilkington, and came out of Lancafter Caftle about the 18th September inft.

EDWARD LYDIATE is about twenty-fix years of age, about five feet eight inches high, lufty, but not corpulent, has a fair complexion, and fandy hair, fhort and lank; wears a blue or brown coat, black waiftcoat, dark fuftian breeches, and a round low crowned hat.

He lately drove a cart for Richard Dickenfon, in Liverpool, but for five months laft drove Edward Miles's cart, in Manchefter, whofe fifter he married.

THOMAS FLEMING is a native of Ireland, about thirty-one years of age, five feet nine inches high, lufty, but not corpulent, of a dark complexion, with dark or black hair, tied; wears a brown coat, with yellow buttons, fpotted velveret waiftcoat, dark velveret breeches, mingled blue and white cotton ftockings, and a narrow brimed high crowned hat, (is in cuftody)

Thefe three men are believed to have negotiated, or offered, feveral of the bills taken out of the mail by the robbers.

Whoever will apprehend any of the Offenders will be entitled to FORTY POUNDS, by Act of Parliament, and the Reward from the Poft Office of TWO HUNDRED POUNDS.

WILLIAM ORRETT, *Poft-Mafter*.

POST-OFFICE, *Warrington, Sept. 30, 1791.*

Reward poster for the murder of James Hogwarth, 1791.

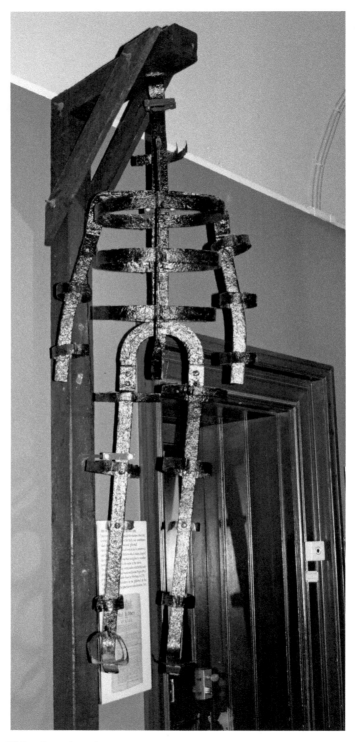

The Woolston Gibbet Irons hanging in Warrington Museum.

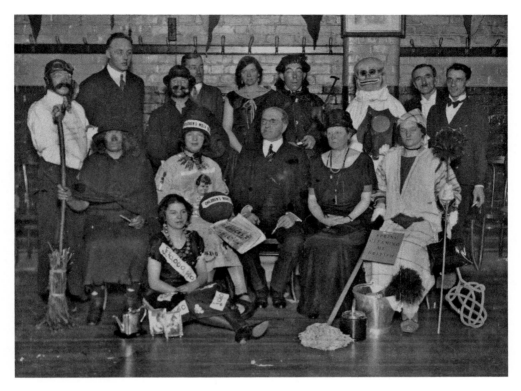

A 1920s local fancy dress party including Spring Heeled Jack (back row).

What most of the descriptions had in common was that Jack would target women, scaring or even assaulting them, then leaping away when the woman cried out. In many descriptions he was said to have leaped over high walls, passing carriages or even rooftops. Over time Jack's appearances start to move farther afield, with a spate of sightings at Liverpool between 1888 and 1904.

On 20 August 1927, the *Warrington Examiner* reported that local residents had seen a very evil-looking man in a black suit prowling around Haydock Street in a mysterious manner. A few days later, between one and two o'clock on Sunday morning, 'a tall figure dressed all in white was seen passing along neighbouring streets and completely disappearing from time to time'. By Sunday night the *Examiner* reports that:

> a crowd of hundreds of people from all over Warrington gathered in Haydock and Furness Streets armed with pokers, bottles, shovels, brooms, carving knives and haymaking implements, prepared to lay the ghost.

At around 11 o'clock the ghost appeared, jeering at the crowd and darting into a narrow entry in Furness Street. At the end of this entry was a high wall over which the ghost was seen to leap 'like the famous Spring Heeled Jack'. Mrs Flanaghan of Furness Street and her three daughters had been among the first to see the ghost that night, telling a reporter

I was standing at the door about eleven o'clock and, happening to look out across the road, I suddenly saw something white. I cried out, 'there it is!' and my three daughters and a young man to whom we were talking saw it too... The apparition was very tall, about six feet, and was covered from head to foot with something white, the only part visible being the eyes ... it ran down the entry, taking off the white covering as it went. We noticed that it had on a dark suit.

Appearances fizzled out for a few weeks but on 10 September at around 10:15 Miss Kitty Evans, aged twenty-six, was sitting in the kitchen at Neston Street, sewing by the light of a gas mantle. She heard a peculiar squealing noise outside and other local residents reported that dogs in the area had howled uncontrollably for several hours.

A week later, Mrs Garner of Birchall Street again heard weird noises and a tapping at her back windows. This was followed by the appearance of man with a very large mouth and an ugly face, lit by a strong white light. Several more sightings were made that night and one household was even awakened to find a pan of bacon frying in their kitchen and a figure running away down the backyard. In Margaret Street a crowd of hundreds of men, women and children spotted 'Jack' and pursued him along the street to a dead end barred by a set of iron railings. The ghost, again in his white robes, shot over the rails like greased lightning.

The crowd were so incensed at potentially losing their prey that they tore the railings out of the ground and followed the ghost up a railway embankment. Here he shone a powerful light in their eyes and leapt over a 10-foot wall of corrugated iron, letting out his trademark high-pitched squeal. It was during this bout of sightings that the Warrington ghost spoke for the first time, announcing his retirement, shouting to the crowd 'I won't be sorry. My time's up on Thursday.' And indeed after Thursday he was never seen again.

This series of events caused no small amount of trouble for Warrington Borough Police but its Superintendent stated, 'We think it is someone playing pranks, and more than anything else that it is women who have got the wind up.' Was Warrington one of the last haunting places of Spring Heeled Jack or was it the site of a series of pranks that got out of control? As the culprit or culprits were never caught the true events of 1927, will forever remain a secret.

DID YOU KNOW
The rumoured network of tunnels across Warrington seems to be an urban myth. However, Joseph Williamson, creator of Liverpool's labyrinth of tunnels, lived in Warrington as a young boy.

3. Forgotten Visitors and Warringtonians

Since the early 1900s, loyal Warringtonians have crowded the town's streets to welcome a succession of royal visitors, but earlier visits were witnessed only by their local hosts within the royal hunting forest of Burtonwood.

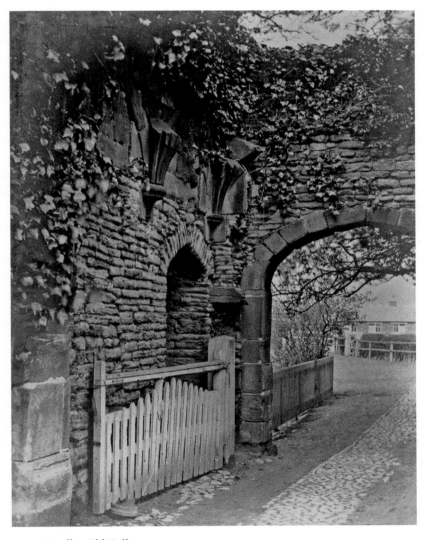

The gateway at Bradley Old Hall.

In 1482, the Duke of Gloucester, the future King Richard III, is reputed to have slept at Bradley Old Hall, while travelling through Lancashire to repel the Scots. Although this medieval building is no longer standing, its moat and gatehouse can still be seen and several features of the Old Hall were reused in the farmhouse later built on the site. Amongst the historical oddities to survive the demolition of the hall was a fifteenth-century bed known as the 'King's bed' and claimed by the Legh family to be the bed Richard III had slept in.

Whilst there is no real proof that Richard stayed at Burtonwood, Peter Legh, who had the gatehouse built, was an avid supporter of the Duke of Gloucester. In 1483, Gloucester was accused of usurping the throne from his young nephew Edward V, who he allegedly imprisoned and had murdered in the Tower of London. The Duke was proclaimed King Richard III and granted Peter Legh £10 a year for life as reward for his loyal support.

Whilst the Leghs may have benefitted from Richard's rise it led to the fall from grace of another important local figure, Friar Penketh. He was one of the most respected religious scholars of his day and head of the Augustine friars in England and Ireland ... and the only local figure mentioned in a play by William Shakespeare. In Act 3, Scene 5 of *Richard III* Penketh (or Penker) is one of two priests summoned by the king to preach sermons in his favour at Easter 1484. This association brought disgrace to Friar Penketh and led to his downfall.

Bewsey Old Hall also lay in the Burtonwood royal forest and from the mid-thirteenth century was home to the lords of the manor of Warrington who played host to two royal visitors. In 1495, the powerful Boteler family entertained King Henry VII on a visit through Lancashire which also saw him open Warrington's important new stone bridge over the River Mersey. By 1602, the hall had passed into the hand of lawyer Thomas Ireland, who numbered King James I amongst his clients. In August 1617, the king made a royal progress through Lancashire on his return from his kingdom of Scotland. On Wednesday 20 August, he arrived at Bewsey where he was entertained and slept in a newly created and decorated bed chamber. He knighted his host before his departure and the bedchamber still survives.

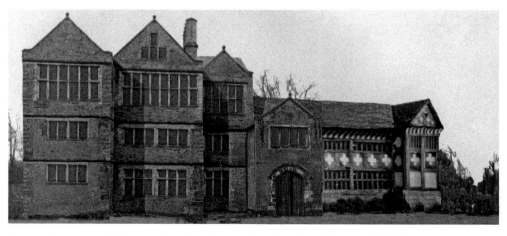

A computer-generated impression of early seventeenth-century Bewsey Old Hall.

Warrington's key location on the national transport network and growing status as an important regional town by the mid-eighteenth century led to increasing numbers of important visitors. The nonconformist academy at Bridge Foot has been celebrated for attracting important tutors such as scientist Joseph Priestley. However, his successor Johann Reinhold Forster's association is less well known. This important natural historian was chosen to accompany Captain James Cook on his second three-year voyage to the Pacific region in 1772.

Whilst Priestley and Forster definitely visited Warrington there is confusion around the town's association with two other important figures of the late eighteenth-century scientific and industrial revolution. Tradition states that clockmaker John 'Longitude' Harrison, who invented the marine chronometer, was resident in Bridge Street near to Market Gate. Harrison's invention of a navigation aid which allowed sailors to accurately pinpoint their position at sea by checking their longitude was widely acclaimed. Warrington proudly asserted his connection to the town, but unfortunately early nineteenth-century local historians seemed to have confused the Yorkshire-born John Harrison with a family of Warrington family of clockmakers also called Harrison.

However, another Warrington clockmaker's rightful claim to fame has been forgotten or at best confused with his namesake. Richard Arkwright is usually credited with the development of a revolutionary spinning frame driven by water which mechanised the process of spinning cotton and was installed in his innovative textile mill at Cromford. In reality the frame was invented by Warrington clockmaker John Kay in 1767, while Arkwright financed his work, patented the invention in his own name and effectively stole the credit. Warrington's Kay not only failed to profit for his work, but historians often confuse him with a Bury-born John Kay who invented the flying shuttle, revolutionising cotton weaving at a similar date.

The original Academy Building at Bridge Foot in 1757.

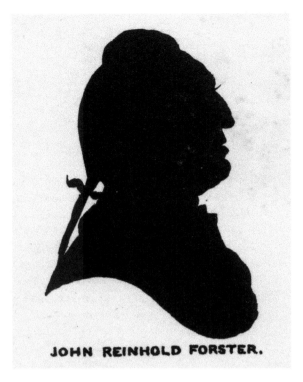

JOHN REINHOLD FORSTER.

Silhouette of John Reinhold Forster.

DID YOU KNOW
Two other Warringtonians not to be confused are James and Steve Donoghue. Sergeant James Donoghue of the 8th Hussars was one of Warrington's Crimean War heroes. He sounded the advance for the famous Charge of the Large Brigade on the battlefield of Balaclava in 1854. He survived even though his horse was shot from under him. Steve Donaghue found fame as Champion Jockey ten times between 1914 and 1923 and won the Derby on six occasions.

William Allcard helped keep Warrington on track in the railway revolution of the nineteenth century. A distinguished railway engineer, he had begun his career as an apprentice to railway pioneer George Stephenson, the chief engineer on the Liverpool to Manchester line. Allcard had overseen the construction of the Sankey Viaduct and took part in the railway's official opening ceremony in September 1830, driving the *Comet* locomotive in the procession. He subsequently worked on other major engineering projects in England and France as well as building locomotives and carriages. By 1839, he was resident in Bank House in Sankey Street and became involved in local politics, first as the unsuccessful Liberal candidate in the 1847 general election before twice serving as Warrington's mayor.

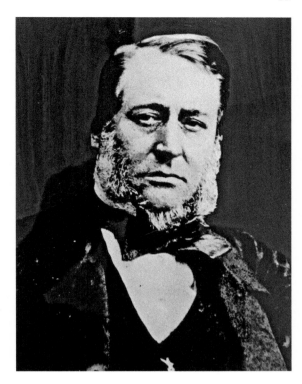

Right: William Allcard, railway engineer and Mayor of Warrington.

Below: William Gladstone at Bank Quay station, 1885.

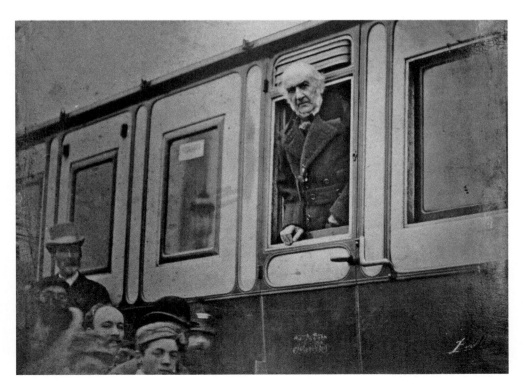

Warrington's new railway links brought many important figures to the town including national political leaders. At 9.30 a.m. on a November morning in 1885, Liberal leader W. E. Gladstone stopped off at Bank Quay station on the campaign trail to Scotland and made a speech to enthusiastic supporters from his railway carriage. This Midlothian campaign set the precedent for a new style of barn-storming election tactics and local photographer J. E. Birtles recorded the moment in a pioneering documentary image.

In September 1905, the town witnessed another significant political event with a visit from Mrs Emmeline Pankhurst, the leader of the Women's Suffrage and Political Union (popularly referred to as suffragettes). Her visit to Warrington came at a time when the WSPU had yet to adopt the more militant tactics of direct action to ensure that women had the right to vote in parliamentary elections. Mrs Pankhurst was a passionate speaker for women's rights and showed how they were disadvantaged in society, but Warrington women had to wait until after the turmoil of the First World War to achieve greater independence.

A number of pioneering aviators also made flying visits to Warrington around this period. First to arrive were hot-air balloonists, including the arrival of Hudson's War Balloon in 1901. Sponsored by Hudson's soap manufacturers, the flights were intended to raise money to support those involved in Britain's war against the Boers in South Africa. It was said that Lady Greenall ventured aloft in a flight over the Wilderspool area of the town and a local photographer took the first aerial photograph of the town showing Greenall's brewery and Stockton Heath.

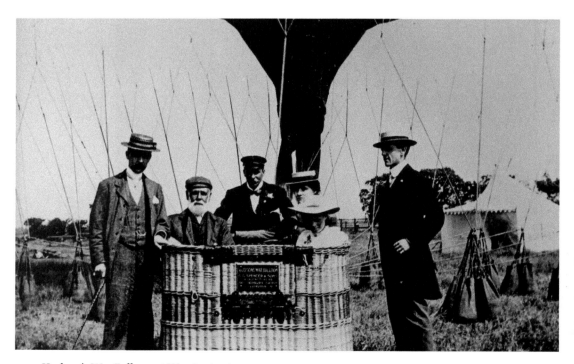

Hudson's War Balloon at Warrington in 1901.

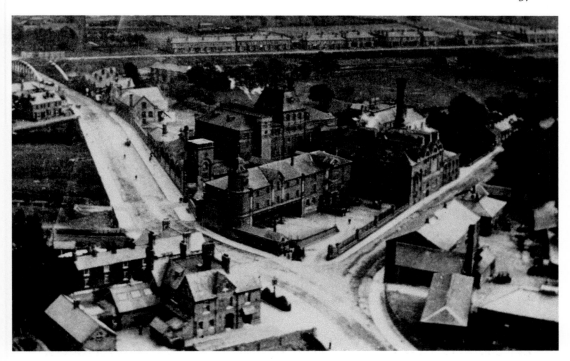

Aerial photograph of Stockton Heath taken from Hudson's balloon, 1901.

At seven o'clock on an early September evening in 1909, excited crowds of Warringtonians witnessed the first flight of an airship over the town. The *Warrington Examiner* recorded that:

The airship came from Manchester and, aided by an easterly wind, was travelling about twenty miles an hour on reaching Warrington .The most prominent feature of the contrivance was an elongated balloon, 80 feet in length and egg-shaped in appearance, Descending from the balloon was a light framework, in the centre of which was a large square basket in which three men were clearly visible... It is interesting to note that the machine is the same in which the suffragettes made a circuit round the Houses of Parliament earlier in the year.

DID YOU KNOW
When the White Star Liner the *Titanic* sank on its maiden voyage in April 1912 with great loss of life, at its helm was a man with a Warrington connection. Captain John Smith had been married at Winwick church and his wife and daughter lived in Great Sankey.

Later that year, on Tuesday August 1912, the first plane to land in Warrington appeared through the smog at Victoria Park to be met with hordes of local onlookers including a range of local dignitaries. The crowd had been waiting for almost three hours when Bentfield Hucks finally appeared in his Bleriot XI-2 monoplane, known as the *Firefly*. A *Warrington Guardian* reporter described for his readers how:

> All eyes searched the heavens and there appeared a small black speck. Bigger and bigger it grew until all could easily distinguish the form of the machine... Gracefully it sailed through space until the now rapidly gathering crowd could hear the hum of the engine. It was a novel and thrilling sight to see an airman travelling over the town at an amazing speed.

The flight from Southport was not without incident, with high winds en route and industrial smog over the town making his landing difficult. Hucks told the press, 'This is a very dirty place. You can see it is Warrington by the smoke.'

The plane was stored for the afternoon in a specially erected hangar, being drawn out again for a special evening demonstration of flying talent. The plane took off, ascended to a height of 3,500 feet, then 'made a sensational dive, sweeping down to within a few yards of earth, only to draw up again and wheel away over the park entrance'. Mr Hucks later lunched at Walton Hall as a guest of Sir Gilbert and Lady Greenall. Warrington had been entertained by one of the country's leading aviators and in 1913, in a different aircraft he became the first Briton to perform looping the loop.

On Sunday 3 July 1932, world-famous aviator Amy Johnson thrilled the town with a flying visit from Barton Aerodrome with her fiancé, Jim Mollison. Both were record-breakers with Amy's solo flight in May 1930 from Croydon airport to Darwin in Australia making her a celebrity across the world, while Mollison had recently completed a record-breaking flight from England to Cape Town in South Africa. Their Sunday visit was the highlight of a 'Great Air Pageant' held at the flying ground on Chester Road where the couple were greeted by the Mayor Alderman Plinston and a crowd of 5,000, including many eager autograph hunters.

Warrington soon became accustomed to aircraft flights over the town with the wartime arrival of first the RAF and later the Americans at Burtonwood Airbase and the RAF training camp at Padgate. When the United States entered the war in December 1941, Burtonwood was one of several RAF airfields offered to the US government. The first Americans arrived in June 1942, and Burtonwood Base Air Depot became responsible for the supply and maintenance of initially all aircraft allocated to the 8th Air Force of the USAAF (the United States Army Air Force). The Second World War transformed Burtonwood from a small Lancashire farming community to the largest American military base in Europe.

During the 1940s and '50s the Yanks of Burtonwood Air Force Base brought Hollywood glamour and US dollars and took home local GI brides. The GIs' homesickness, low morale and the fears of war were swept aside with visits by international celebrities and stars who entertained the servicemen and women on makeshift stages erected in supply hangars. Bing Crosby and Bob Hope visited Burtonwood on several occasions together

with film actors James Cagney and Broderick Crawford, band leaders and musicians including Glenn Miller, Joe Loss, Irving Berlin, Nat King Cole and Vera Lynn. Military and political leaders also visited the base including US Generals Eisenhower and Patten and Britain's Field Marshall Montgomery and later royal visitors included Prince Philip and Prince Charles. Meanwhile, amongst the young RAF cadets completing their post-war National Service at Padgate Camp was future Rolling Stone Bill Wyman.

Warrington's entertainment venues both large and small also brought many famous performers to the town. The Public Hall in Rylands Street, which later became the Royal Court Theatre, brought major nineteenth-century figures. It twice advertised performances by literary giant Charles Dickens ... but did both take place?

Dickens's writings mixed comedy and pathos with portrayals of the social issues of mid- nineteenth-century England. Long before the era of televised soap operas Dickens ensured that his serialised novels had cliff-hangers to keep his audience eagerly awaiting the next instalment of his larger-than-life characters. Since only a small proportion of his prospective audience could read Dickens took to the stage to give dramatised performances from his most popular works and also enhance his fortune. He was a gifted and enthusiastic performer but his tours became increasingly exhausting, as Warrington was to discover.

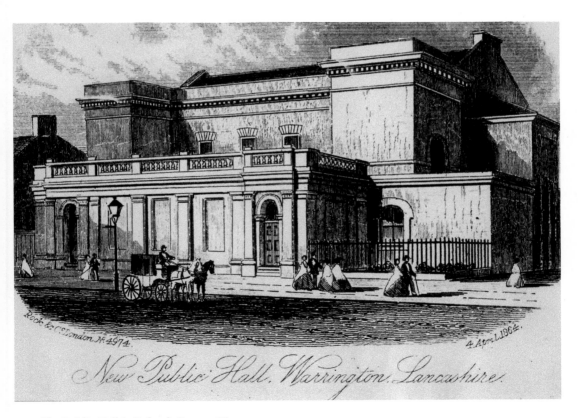

The Public Hall in Rylands Street, 1864.

On 2 May 1867, Charles Dickens entertained a packed audience at the Public Hall in Rylands Street, as the *Warrington Guardian* reported:

Every man of note seemed to be present. Until ten o'clock Mr Dickens ... kept the close attention of his audience, frequently, however, relieved by loud bursts of applause... Mr Dickens begins to show marks of age, creeping on is a good sprinkling of grey hairs, but time deals gently with him on the whole and ... although called a reading, not a word of it did Mr Dickens read during the whole two hours.

Alas age and increasing ill health threatened his keenly awaited return visit exactly two years later in May 1869. The previous October Dickens had begun a gruelling farewell national tour where his dramatisation from *Oliver Twist* of the murder of Nancy by Bill Sikes electrified his audience but also saw Dickens being helped offstage afterwards. By April 1869, his exhaustive schedule had included Scotland, Ireland, East Anglia, Manchester, Sheffield and Birmingham, culminating in a great banquet held in his honour in Liverpool.

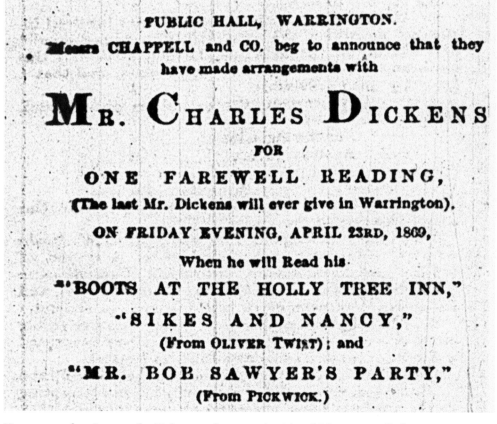

Newspaper advertisement for Dickens performance in 1869, which was cancelled.

Whilst resting in Chester on 18 April he suffered an apparent stroke but continued to deny that the tour was overtaxing his health. He insisted on continuing to Preston but a visit by his hastily summoned London physician saw the evening's sold-out performance cancelled and also his scheduled appearance in Warrington.

Dickens died in June 1870 leaving his last novel, *The Mystery of Edwin Drood*, unfinished. Warrington had one final part to play in Dickens's story as the novel was illustrated by acclaimed local artist Luke Fildes, who also published a popular engraving of his empty chair in the study of his home at Gad's Hill.

In May 1903, an even more flamboyant entertainer, Colonel W. F. Cody, alias 'Buffalo Bill', swept into Warrington, as the *Warrington Examiner* recorded:

> Nearly 20,000 spectators witnessed Buffalo Bill's Wild West Show at Wilderspool on Monday afternoon and evening... One of the most exciting events was the 'Cowboy fun', which consisted of picking objects from the ground while going at full gallop, lassoing wild horses, and riding the bucking broncos. Indians from the Sioux, Arapahoe, Brule, and Cheyenne tribes gave a picturesque illustration of an Indian skirmish and tribal war dances, which were highly interesting.

More traditional entertainers could be seen at the Parr Hall, which has been a versatile and much-loved concert venue for over a century since it was presented to the town as a public hall by J. Chorlton Parr, a member of the wealthy local banking family in 1895. Ballerina Anna Pavlova performed before an appreciative audience on Tuesday 25 October 1927. The *Warrington Examiner* reported that Pavlova was 'like some ethereal being from the realms of fairyland bringing beauty into a drab world' while the *Warrington Guardian* stated, 'In this age devoted to Jazz and Fox-Trot, there are still those who make dancing a real art and inspiration.' Interviewed after the performance Pavlova said, 'I am absolutely enthralled by the Warrington audience; they are too beautiful for anything.'

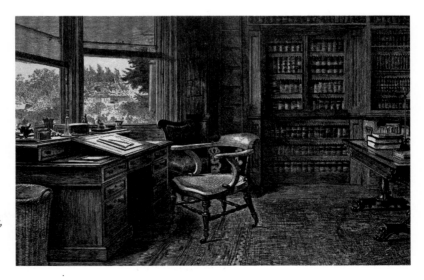

The Empty Chair, engraving of Dickens's study by Luke Fildes.

These are thought to be performers from Buffalo Bill's show.

Other famous acts included singer Paul Robson and the ever-popular comedian Ken Dodd while newer generations of music fans could enjoy an emerging band called the Rolling Stones and later Stone Roses' come-back gig in 2012.

However, in the 1960s it wasn't unusual for Bewsey music fans to find pop stars like Tom Jones playing on their doorstep at the former Towers Labour Club opened in July 1948. Acts included a new pop group called the Beatles (including Ringo Starr) and they carried all their own gear on stage. The audience had paid seven and sixpence (37½ pence) to hear them perform and one remembered seeing them first on that evening's edition of Bob Greave's TV show *Scene at Six Thirty*. Paul McCartney launched the band into a request performance of their new No. 1 hit 'Love Me Do'. The Beatles' concert at the Bell Hall in July 1962 has been well documented, but the Bewsey gig seems to have slipped under the radar of popular music historians, unlike the acts at Mr Smith's nightclub, scene of the *Hit Man and Her* televised performances.

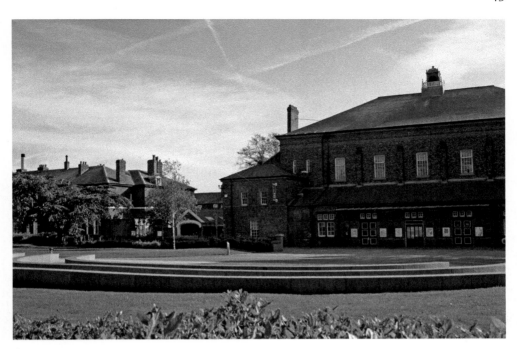

Above: The Parr Hall seen from Queen's Gardens.

Right: Paul Robeson's signed programme from his 1930 Warrington concert.

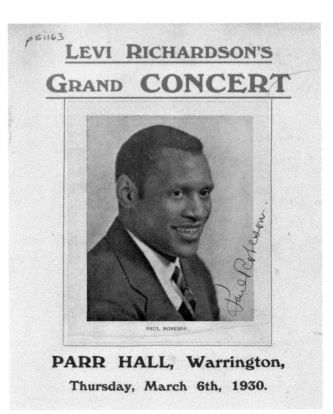

The Towers Labour Club at Bewsey.

4. Ordinary and Extraordinary Stories

Before the days of social media few Warringtonians chronicled their daily lives and few could read or write until the later nineteenth century. From 1853, the *Warrington Guardian* recorded key events in the town, but at first few stories of 'ordinary' people appeared in their columns, unless they featured in court cases. A combination of press stories, government reports, council records and other documents in official archives reveal tantalising glimpses of lives which would otherwise be hidden from history. However, to complement these a few Warringtonians kept diaries, recording contemporary accounts of life in the town from their perspective.

Roger Lowe's diaries cover the period of 1663–78 and the turbulent years in the aftermath of the English civil wars of the 1640s, the restoration to the throne of King Charles II and the days of the great plague. Although resident in Ashton-in Makerfield, he records visits to other areas of the town and especially Winwick. Without access to rolling coverage of national events, his diaries focus on mundane everyday events, but in January 1665 he came face to face with local history, writing:

> Hugh Toppin of Warrington told me that there was the head of some Christian lay bare to public view above the ground and that it was a charity to bury it which I said I would do... I went to bury it (and dug) the hole with my hands. It was said to have been a Scot and there slain when Duke Hamilton invaded England.

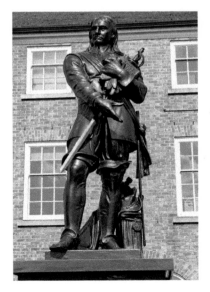

Oliver Cromwell's statue in its new position at Bridge Foot.

Lowe provided a direct link to the events of 19 August 1648, when Oliver Cromwell and his army pursued the defeated Scots and Royalist forces down the main road from Preston. The Scots, led by the Duke of Hamilton, made a last stand against the Parliamentary forces at Red Bank, a narrow stretch of lane halfway between Newton and Winwick. Cromwell reported that around 1,000 of the enemy had been killed there and at Red Bank, and that around 2,000 prisoners were taken, many being incarcerated temporarily in the church itself.

CHOLERA.

The disease so called which appeared at Sunderland in October, /8 has extended itself to Newcastle and several other Towns in that Neighbourhood and it is greatly to be feared (unless through God's infinite mercy the plague be stayed) that it will prevail throughout the kingdom : ---It is therefore earnestly recommended to all persons that they attend most seriously to the following remarks---

I.—That the disease is of the most pestilential and fatal nature, frequently producing death in a few hours after the first symptoms.

II.—That it makes its appearance, remains longest, and is most dangerous in close, damp, dirty, houses and neighbourhoods.

III.—That persons of irregular, dissolute, and drunken character, are most liable to its attacks, and that amongst such it is deadliest and most contagious.

You will, therefore, as you regard your own life, and the lives of all connected with you, carefully follow such rules as will conduce to your well-being, and abstain from all those things which are likely to produce or propagate so terrible a calamity.

1.—You will be careful to keep your house clean and in good order : if it wants repairing you will mention it to your landlord, overseer or minister, at the first opportunity.

2.—You will keep a thorough draught of fresh air in every room by keeping the windows open during the day : you will also turn down the beds in the morning and let the pure air blow upon them : you will remove the damp, as far as possible, by keeping up the fire.

3.—You will cultivate bodily cleanliness.

4.—You will avoid crowding many people into the same bed-room.

5.—You will live regularly and soberly, and avoid by all means persons of opposite habits, inasmuch as the disease is most likely to be caught from such people.

6.—You will, it is hoped, consider the threatened visitation as a loud call for increased attention to the duties of religion,—especially those of public and family worship.

7.—You will use all your influence amongst your friends and neighbours, that they, following your example, may so conduct themselves, that the disease may, either be turned aside from us, or at most appear in so mild and partial a form, as to be of small importance.

8.—You will acquaint some gentleman of influence, as the clergyman or overseer, or if you consider it of importance, you will apply at once to the magistrates,—should there be any nuisance in your neighbourhood, any thing offensive, or prejudicial to health, any disorderly houses, any of those filthy places in which it is known that pestilence always begins, or should any case of sudden death accompanied by vomiting and purging, come to your knowledge. J. R.

Warrington Dispensary, January 4th, 1832.

MALLEY, PRINTER, WARRINGTON.

Guidance for the Warrington cholera epidemic issued in 1832.

Writing in the 1830s Martha Rylands, wife of wire manufacturer John Rylands, was also conscious of the precarious nature of human life. In June 1832, Warrington fell victim to the cholera epidemic which had been sweeping through the country since the previous autumn. A cholera hospital was set up in Mersey Street to deal with the high numbers of people expected to die. Writing in her diaries after the epidemic was over Martha Rylands records her experiences of living through those terrifying times:

Oh the consternation the town was in – The Cholera! Gracious Lord thy Judgements were beginning. Oh the horrors of that time. On the 20 Miss Kerr died – I had seen her on the Tuesday in perfect health! I cannot write the accounts of that time – nor even think of those weeks without a sort of horror & trembling coming over me – So many hurried into eternity!

Mr. and Mrs. Edelsten died sometime about now – I don't know the days – for much was my state of excitement that they dare not tell me! On the 17th Mr. Wm Smith died! Oh it was again a most awful time! On 27th I heard that Sarah Edelsten – daughter to Mr. Edelsten – was dead! A most interesting young girl one of our Bible collectors – Oh it is heart rending! – ... Dr. Kendrick says it will return worse than ever – and in the higher class! But – how should he know – May the Lord protect us!

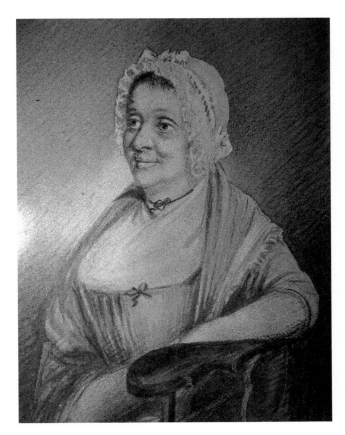

An uncharacteristically cheerful image of Martha Rylands.

As Martha's is one of the few detailed accounts of the epidemic written by the town's non-medical inhabitants, it is difficult to know how typical her reactions were, but her religious views meant that she would probably have welcomed an early death to be reunited with her maker. After the Covid-19 pandemic of 2019 onwards, however, many will identify with the impact the crisis had on her mental health.

Tryall Holcroft gave a more measured view of life in the town in his diaries. Holcroft had spent his working life in the silk industry around Manchester but aged seventy he was finally able to make an extended visit home in August 1879:

> For many years it has been my wish to go over to my native town 'Warrington', spend a few days there in visiting the scenes of my childhood, for I have been brought up elsewhere since I was 10 years of age... It is 49 years since I was in or about the town; in fact with a few exceptions I did not recognise the streets, for they are many and new. The town then may have had 12 or 15000 inhabitants; now I guess 40 or 50000, chiefly employed in the iron trade, forges and wire works, and glass. A few years ago operatives earned high wages ... which as a rule they spent foolishly. Now they are short of employment and in deep distress. When I was there I saw 200 of them breaking stones in the Workhouse yard for 1/6.

Official sources document the hardship Holcroft mentions. In 1843, the Child Employment Commission reported on Warrington's pin-making industry and their report gives a rare glimpse into the harsh lives of those employed there, including Edelsten's Oliver Street works off Winwick Street.

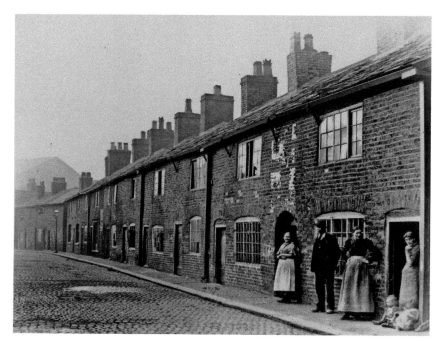

Oliver Street near Winwick Street *c.* 1900.

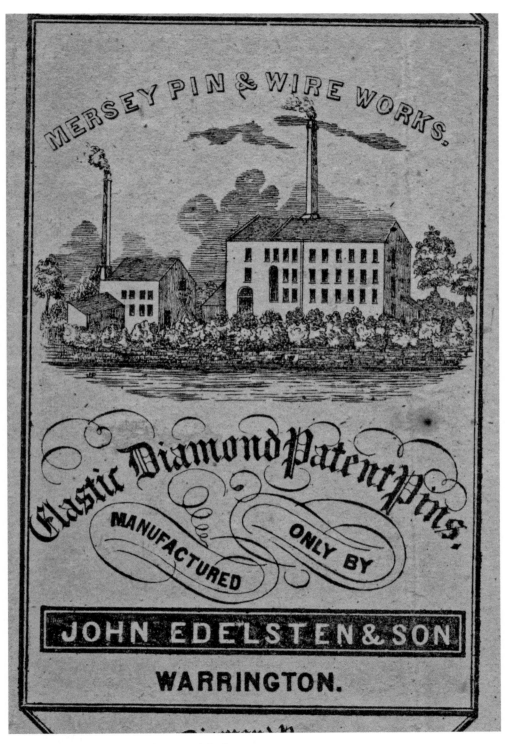

Advert for Edelsten's pinworks at Latchford.

Each side of the street has cottages of two stories high, inhabited by the labouring classes, and sundry passages ... leading to the pin-heading shop, which is partly the ground floor of a building two stories high and partly a shed built to lengthen out the lowest storey... The length of the whole is 40 feet, width 12 feet 10 inches ... there are nineteen casement windows, a small stove at one end and a fire at the other... There were fifty three persons in this room, of whom thirty four were under thirteen.

Warrington's child pin-makers often worked up to fifteen hours a day, starting at half past five in the morning and often finishing at eight in the evening with minimal meal breaks. Not surprisingly they were often delicate and feeble and died young. In 1910 the *Warrington Examiner* gave a vivid picture of the lives of children living in the town centre slums:

Official figures show that in certain districts one child in every four dies before it reaches the age of one year. We who associate children with cosy cots and ... all the clean rosiness of the loved babies of the well-to-do cannot have any real conception of the life of the slum child.

About five minutes walk from the town hall houses can be found almost festering with dirt. Back yards are unpaved, dust of the street and of the yards is polluted with filth of every kind ... the wind blows the dust into the houses, the germs enter a little body, diarrhoea becomes prevalent: the child poorly bred, badly nourished, insufficiently clothed, is unable to withstand the attack and quickly dies.

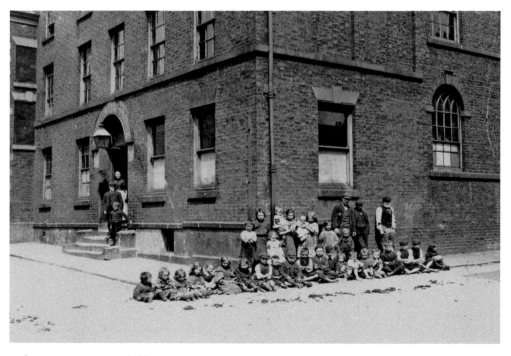

Unknown Warrington children outside the Ragged School in Bank Street.

As Warrington's population grew in the nineteenth century the town's officials were made responsible for those who could not earn enough to care for themselves, including orphans, deserted wives or widows, the elderly and the chronically sick. Those in desperate need had to enter the workhouse as there was no benefits system. The Poor Law of 1834 had grouped areas into Poor Law Unions which for Warrington covered the area of Warrington, Newton-le Willows, Hulme, Penketh and Cuerdley. This meant the Guardians who administered it potentially were responsible for 28,000 local residents plus the so-called 'vagrants' passing through. The existing workhouse in Church Street, opened in 1729, was deemed inadequate and in 1849–51, a massive new complex was built off Lovely Lane with its entrance in Guardian Street.

In 1913, a reader of the *Warrington Examiner* recalled the old Church Street workhouse and its infirmary:

> There was not a single beautiful feature about it... The workhouse infirmary was not a big place ... the old women inmates wore white caps and looked very well. An artist could have made a good picture by copying the old folks as they sat out in the sun or gathered round the tables for food.

Cicely Pusill, one former elderly inmate, may have had a less sentimental view as she had been the last woman in the town to have been imprisoned in the infamous 'Scold's Bridle' for wandering around the town shouting at passers-by. The sad reality was that she may well have been suffering from a condition like dementia and deserving of care but was regarded merely as a nuisance.

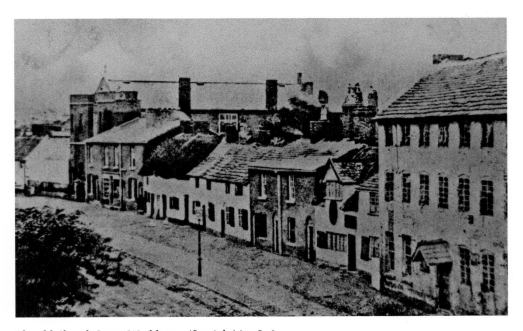

The old Church Street Workhouse (far right) in 1856.

A romanticised view inside Chelsea Workhouse by Warrington artist James Charles.

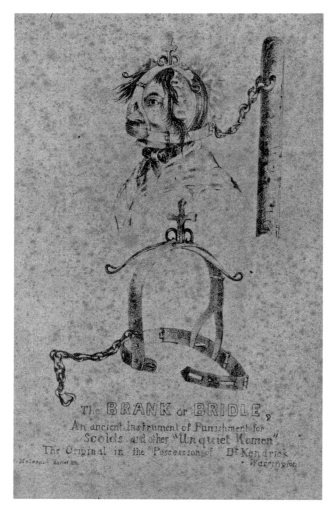

The archaic Scold's Bridle clamped the woman's mouth shut.

After 1834 life became even harsher inside the workhouse to ensure only the most desperate would enter. There was accommodation for 314 men and 314 women as long-term residents and even married couples and brothers and sisters were segregated. There were separate casual wards for vagrants, an infirmary, isolation ward, dining hall, kitchens and chapel but inmates found it almost impossible to return to life outside.

DID YOU KNOW
Many Warrington children's birth certificates register them as being born at 99 Guardian Street. In reality they had been born in the workhouse but to avoid this stigma of poverty following them for the rest of their lives they were registered at a more anonymous address.

In 1880–81, the Union set up a separate Industrial School at Padgate (later renamed Padgate Cottage Homes) to provide accommodation, education and training for 200 poor children who were either orphaned or whose family circumstances meant they needed to be taken into care. Boys and girls were separated into separate blocks managed by either foster mothers or a married couple. Many of the children compared their time at the home favourably with their previous hardships, while others found the experience more traumatic. Few official records survived after its closure in 1954, but under data protection such sensitive material is hidden from public view for a century.

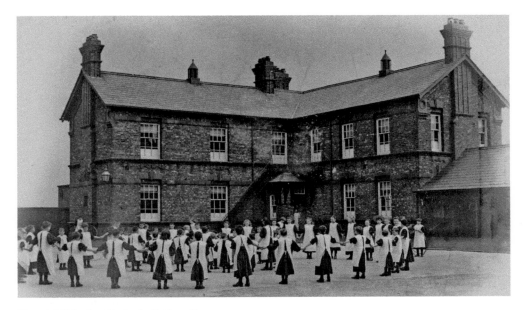

The girls' block at Padgate Cottage Homes.

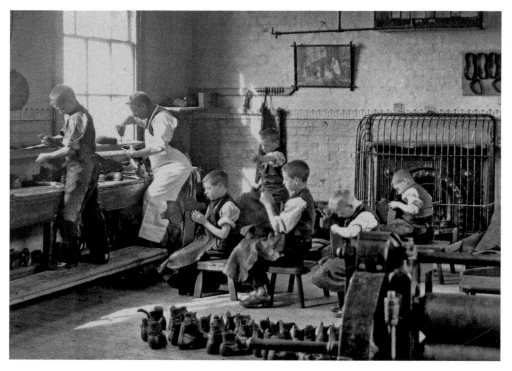

Boys learn a trade at Padgate Industrial School *c.* 1900.

Life in the Guardian Street workhouse had changed by the 1890s, when a more tolerant and sympathetic official policy allowed a more humanitarian and understanding regime. In 1900, the Warrington Union Infirmary was added, consisting of two wards to care for the chronic sick and maternity cases. Later known as Whitecross Hospital, the building was taken over by Warrington Borough Council in 1929 and subsequently renamed the Borough General Hospital.

The introduction of the Welfare State in the late 1940s was intended to remove the stigma attached to poverty and support people out in the community. However, it was another half century before policies towards those with mental health issues moved away from the practice of incarceration in asylums, often for life. In 1894, Lancashire County Council was anxious to find a site for a new asylum in south-central Lancashire and bought a substantial estate of 207 acres at Winwick. The county asylum was built between 1895 and 1902 as a self-contained community with a carefully designed layout to accord with the prevailing ideas about the care of the so-called mentally ill and mentally disabled.

The asylum, like others in the county, was huge – in 1915 it had over 2,100 patients and by 1950 it was as large as a small town with some 3,000 residents and staff. Its inmates were effectively hidden from history and the stigma of a relative in a so-called lunatic asylum meant they were rarely spoken of, even within the family. By the end of the twentieth century the philosophy of mental health care had changed: large institutions were no longer acceptable, and in 1999 the hospital closed.

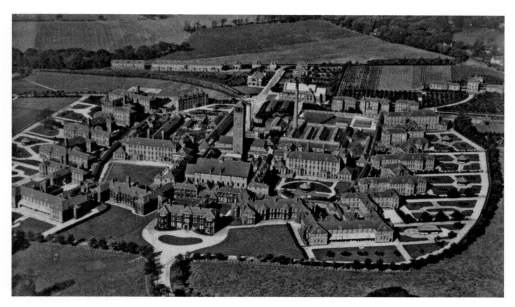

An aerial view of Winwick Asylum shows the scale of the site.

The lives of disabled people have often been overlooked or purposefully hidden in the history of a town, and until relatively recently all manner of barriers were put in the way of disabled people trying to tell their own story. William Stewart Royston, who styled himself as 'The Walking Stick King', takes on an important role in the history of Warrington. Royston was born on 10 October 1863 at Cinnamon Brow and died in 1944 at the age of eighty. His father, William senior, was a manufacturing chemist who owned the Paddington Chemical Works, and by the time William junior was a boy, the family were living at Paddington Grange on Manchester Road.

Around the age of sixteen, while a student at Boteler Grammar School, William suffered an illness that left him blind and completely paralysed down his left-hand side. His sight gradually returned, but the paralysis remained for the rest of his life. In an age when mobility aids were rare and attitudes to towards disabled people were different, William spent much of his life confined to his bed. However, William had a powerful mind and a strong concern for the well-being of others. These traits drove him to find ways of helping those in need from the confines of his own house.

Throughout his life William organised extensive fundraising and letter-writing campaigns for a wide variety of national and local charities. He wrote to people all over the world and published articles in a wide range of newspapers and magazines raising awareness of various good causes. The pinnacle of that charity work was arguably his scheme to provide walking sticks to disabled servicemen during the First World War. By 1919, Royston had provided over 25,000 walking sticks to injured servicemen. His work led to letters of thanks from lords, bishops, ministers and prime ministers from across the world, and even a much-treasured letter of thanks written by Queen Mary.

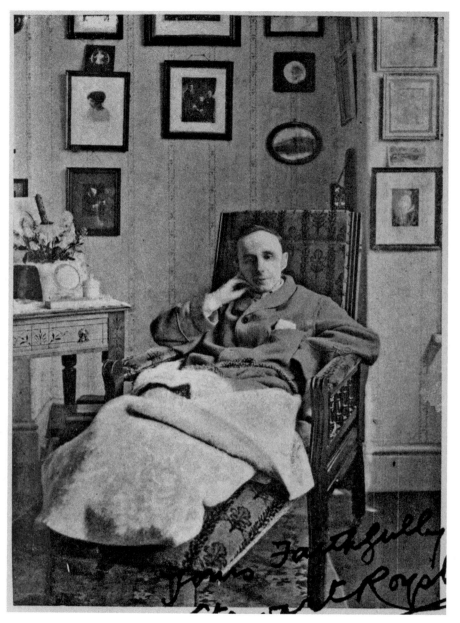

William Stewart Royston, the 'Walking Stick Man'.

Other apparently ordinary Warringtonians carved out a niche for themselves as local characters. During the Second World War, Frank Norman became known as 'The Black Out Man' who tried to bring cheer among wartime austerity. This former musician from Norfolk had fallen on hard times when he was discovered by a local policeman sleeping rough under the statue of Oliver Cromwell at Bridge Foot. With support from local

traders he soon had a regular spot outside the Barley Mow Inn, wearing distinctive white make up, black tail coat and top hat. He played classical music on a battered wind-up gramophone carried on an old black pram donated by a local pawnbroker. Frank and his pram were decorated with patriotic slogans such as 'Keep Smiling' and 'God Save the King' and he was a favourite of local children. On his death in May 1952, local traders paid for his funeral.

Poet, philosopher and fishmonger Charlie Lee was also a distinctive feature of the old market area in the 1950s because of the daily poem he wrote on his stall. Writing in the *Warrington Guardian* in 1969, Dr Johnson Ball recalled:

> In the corner near the Barley Mow was Charlie Lee's oyster stall. When he was ready for business Charlie hung a glass case containing a crab's claw which appeared to be the exact shape of a human leg. He also wrote poems which he put up for people to read. He was quite a character.

Meanwhile, Warrington's 'Secret Artist', Eric Tucker, kept his talent closely guarded from all but close family members. Over the course of more than sixty years, while working as a labourer he created images of the world he knew: working-class life in the industrial north. He made few attempts to exhibit or sell his paintings and few beyond close family had seen his work. After his death in July 2018, the full scale of his life's work finally came to light. His family found more than 400 paintings (and thousands of drawings) stacked up in every room of his house in King George's Crescent – in cupboards, on top of wardrobes, in the attic and even the garden shed.

Charlie Lee stands to the right of his poem at his fish stall.

Eric seemingly had no desire for art world recognition or success during his lifetime and after his death his family were overwhelmed when hundreds queued to see an intimate weekend showing of his work in Eric's home. A hugely popular exhibition followed at Warrington Museum, honouring Eric's wishes for his work to be shown in his home town gallery. By now the national media had discovered his work and some art critics dubbed him 'Warrington's Lowry', but many local visitors to the exhibition claimed he was 'better than Lowry!'

The story of 'Happy Ned' had also made newspaper headlines around the world in 1888, but perhaps it seems less remarkable in today's gender fluid age. Born in 1831, farmer's daughter Elizabeth had married a local farm labourer named Taylor. After the marriage broke down Elizabeth decided to 'throw off her woman's clothes for male attire'. Dressed and self- identified as Ned Davies, he worked as a navvy and farm labourer and even served as a sailor in the American Civil War. Returning to England, Ned took to drink and soon found himself in trouble with the law as either Ned or Elizabeth, as the *Warrington Guardian* reported in his/her obituary in September 1887:

> She was first brought before the magistrates at Warrington in the year 1872, when she was charged with being drunk and disorderly in the Eagle and Child yard, and was fined 5 shillings including costs. She was then dressed in male attire. She was subsequently charged with similar offences at the Police Court, and on each occasion she was dressed in men's clothes, but in 1885, when she was locked up for being drunk and disorderly on Town-hill, she was dressed in feminine attire, and so complete was the change in her appearance that neither the Magistrates' Clerk nor the Chief Constable recognised her.
>
> Deceased, who had lived in the Narrow Wyn, off Buttermarket-Street, was 56 years of age, and is described on the 'character sheet' at the Police Station as the wife of Andrew Davies of Penketh. The funeral, which took place on Monday afternoon, is said to have been 'a very respectable one'.

Artwork by Eric Tucker displayed for the exhibition at his home.

5. Herstories

While, the lives of ordinary people have long been hidden from history, even women from wealthier backgrounds have been underrepresented. In the 1970s, feminists asserted that the past had always been told from a male perspective and coined the term 'herstory', emphasizing the role of women and uncovering their stories.

Even if the lives of women from a wealthier background had been noted this was usually linked to their male relatives. As the daughter of the Lord of the Manor, John Blackburne of Orford Hall, Anne Blackburne (1726–93) had connections to many important scholars who shared his interest in horticulture and natural history, including Linnaeus, who named a variety of American Warbler after her (*Sylvia Blackburniae*). She was so well respected that her obituary was included in a national *Obituary of Considerable Persons* in the *Gentleman's Magazine*.

Anna's contemporary Anna Barbauld (1743–1825) may have had advantages through her family but her own talents made her one of the best-known writers in contemporary society. Through her father, Dr John Aikin, a tutor at Warrington Academy, she gained unofficial access to a higher education usually denied to women. Her brother encouraged her literary career but her husband, Rochemont Barbauld, a former pupil at the academy, became increasingly jealous of her fame, contributing to the breakdown of their marriage.

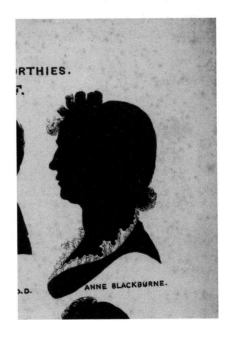

Anne Blackburne of Orford Hall.

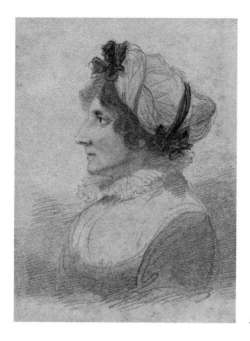

Anna Laetitia Barbauld (née Aikin), 1743–1825.

Anna was initially revered by contemporaries such as William Wordsworth and her poem in support of Corsican independence gained recognition beyond the provinces–although it was assumed that this powerful work could only have been written by a man. After 1774, Anna became a recognised figure in London's literary and artistic society and was adopted by the Blue Stocking Circle of academic women. However, she was not a feminist writer, rather a woman who dared to campaign against slavery and in favour of American Independence, subjects judged to be the preserve of men.

Initially, she supported the French Revolutionaries and opposed Emperor Napoleon, but by 1811 she felt that Britain was misguided in continuing the war. She suffered a public backlash as her writing was judged unpatriotic and even treasonable. Many of her works fell out of print after her death in 1825, but more recently American feminist academics have championed the significant role she played in shaping intellectual ideas.

Although Anna Barbauld's Warrington connections are comparatively well known, Elizabeth Gaskell is usually only linked to Knutsford or Manchester. Her husband, William Gaskell, had a family connection with Latchford and the nonconformist Cairo Street Chapel off Sankey Street in Warrington. Elizabeth settled into the life of the wife of the minister of Cross Street Unitarian Chapel in Manchester and with her husband's encouragement began to write short stories. However, in 1845 their nine-month-old son William died in an outbreak of scarlet fever and was buried in the graveyard of Cairo Street Chapel. Elizabeth was distraught and later wrote of 'My darling, darling Willie who now sleeps sounder still in the dull, dreary chapel-yard at Warrington.' Her husband suggested that her writings could be a distraction and local tradition suggests that she was staying at the home of family friends in Latchford when she began writing *Mary Barton*, her first novel.

The graveyard of Cairo Street Chapel.

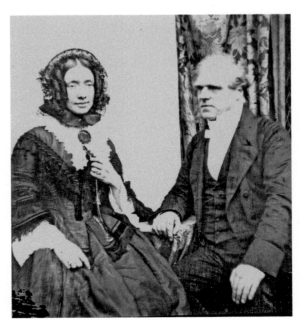

Fashionably dressed Louisa
Quekett and her husband,
Rector William Quekett.

Louisa Quekett was very conscious of her status as the wife of William Quekett, who became rector of Warrington in 1854, and committee work for various local charities kept her at the forefront of local society. However, perhaps she protected her status too fiercely by ensuring that her husband's young curates did not overshadow him as in 1885 a thinly disguised portrait of the Queketts featured in *Battleton Rectory ... or the Curate's revenge*. Written under the pseudonym of Quentin Murray, the short novel clearly equated Battleton with Warrington and Reverend Thomas Lyman's campaign to rebuild his church. Louisa was satirised as imperious Jessibella Lyman – a she-devil who hounded out the curates who displeased her! Rector Quekett swiftly bought up and destroyed all copies of the book – although at least one survives in the local archives.

Fifty years after the death of Anna Barbauld Warrington witnessed the birth of another pioneering woman writer, Beth McFall, who broke away from her husband's shadow and reinvented herself as Sarah Grand. Beth McFall (1854–1943) came to Warrington at a pivotal moment in her life in 1874 when her marriage was failing and she was about to embark on a career as a controversial feminist author. She scandalised Warrington society by leaving her husband, army surgeon Sergeant McFall, to embark on a literary career in London as Sarah Grand. Her early books such as *The Heavenly Twins* controversially discussed the impact of sexually transmitted diseases on women victims.

Sarah Grand (formerly Beth McFall).

In 1902 *The Dawn*, a monthly Warrington magazine, claimed:

We ought to be extremely proud of the fact that this brave and gifted woman who, almost alone among her sex, has dared to speak the truth on topics which 'society' taboos and wrongs, which it would sooner tolerate than discuss, resided in our midst so long. She wrote several volumes here and issued Ideala the first volume of The Heavenly Twins, from a Warrington press. Her earliest novel published in yellow paper covers at the (Warrington) Guardian Office in 1888 was garnered for the local multitude.

Anna Laetitia Aikin... Sarah Grand: almost a century between them, but these are names which Warrington should not forget.

Sarah became an active campaigner for women's rights, declaring, 'We shall do no good until we get the Franchise, for however well-intentioned men may be, they cannot understand our wants as well as we do ourselves.'

Grand lectured throughout England and the United States, promoting women's suffrage. However, like Anna Barbauld, her pioneering writings were largely forgotten until the late twentieth-century feminist movement.

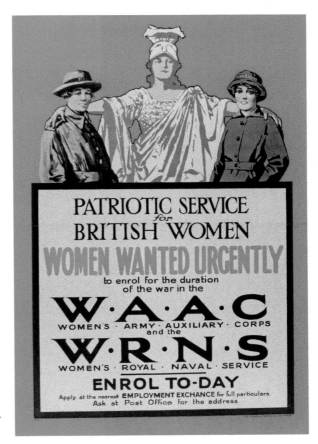

First World War recruiting poster for women to play their part.

Many Warrington women were also fighting for the right to vote. While some were Suffragists, campaigning peacefully through petitions and political lobbying for the right to vote, a smaller number, including Warrington's first female journalist, Mabel Capper, joined the more militant Women's Social and Political Union begun by Emmeline Pankhurst in 1903. Her supporters became known as suffragettes because they were prepared to disrupt political meetings, stage violent protests and go on hunger strike in prison. The suffragettes are often credited with winning votes for women in 1918, but this owed as much to the role women had played during the First World War. They had proved that they were far from the weaker sex by stepping up to successfully take on men's roles. Once Britain's men were conscripted into the armed services in mid-1916 Warrington women were called on to fill key gaps in the labour force – from factory workers, to bus drivers – and by June 1918 nearly 30,000 women worked on farms around Warrington and neighbouring Cheshire villages.

Meanwhile, Warrington's Lady Frances Greenall (1874–1953) demonstrated she was more than just the wife of wealthy local brewer Sir Gilbert Greenall. She was described as the Conservative Party's most useful local asset, even before women were given the right to vote. During the First World War, she took a major local role, initially by supporting Red Cross appeals at home. From 1915, she saw front line action in France by running a YMCA-supported recreation hut for soldiers off duty and for visiting relatives of badly injured casualties.

Local land women harvesting in 1917.

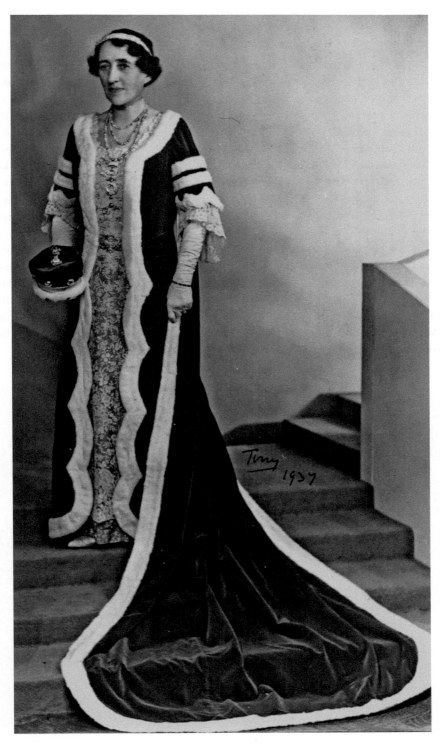

Lady Frances Greenall stands regally in her peeress' robes.

By 1918, Lady Greenall was back from the trenches and set up the Blighty Club in the Conservative Club in Sankey Street as a recreation centre for the servicemen to help them recuperate or provide comradeship. When Sir Gilbert was given a peerage in 1927 as recognition for his war work, many felt the new Lady Daresbury had earned the honour.

The Broadbent sisters also took on important war work. Their father, Charles Broadbent, had served on the town council as a Liberal politician, twice serving as Mayor of Warrington. After his death and the loss of two brothers in the Boer War, the sisters owned a major Latchford tannery and played a major role in village life. The war gave them the opportunity to display their fighting spirit, including youngest sister Lucy, who had been involved with the suffragette movement.

The British Red Cross Society provided an opportunity to demonstrate their patriotism and organisational skills. From 1914–19 the sisters effectively operated a military hospital under the control of the War Office but entirely dependent on voluntary contributions. Raddon Cross Hospital stood conveniently across the road from their Latchford family home at the Hollies, whose grounds were also used by convalescing patients. As Vice President of the Daresbury Division, Sylvia Broadbent worked tirelessly in a fundraising role, while younger sister Margaret was hospital commandant as head of Cheshire No. 22 Voluntary Aid Detachment. By May 1919, her superintendent, three trained nurses, eight Red Cross nurses and volunteers, two doctors and auxiliary staff had tended to over 1,600 patients from a variety of nationalities.

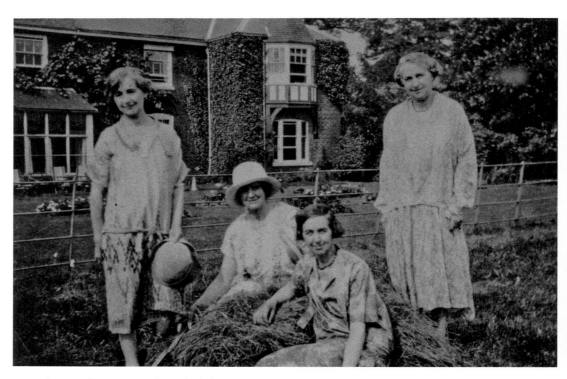

The Broadbent sisters: from the left, Sylvia, Margaret, Lucy and Constance.

Raddon Court hospital at Latchford.

Meanwhile, Lucy was serving as a nurse on the front line in Rumania in an all-female medical unit. All three sisters were decorated for their war work with Lucy receiving a Russian medal for bravery under fire. They remained stalwart supporters of the British Red Cross Society into the Second World War.

DID YOU KNOW
May Westwell became the town's only female fatality on active service in the First World War. Before the war she had been a teacher at Evelyn Street School, but in wartime she served as an assistant administrator at the Queen Mary's Auxiliary Corps in Dublin. Sadly, in October 1918, she was travelling on HMS *Leinster*, the Holyhead mail boat, to make a surprise visit to her family when the ship was torpedoed off the Irish Coast by a German submarine and sank without survivors.

The 1918 Representation of the People Act gave some women the right to vote in parliamentary elections and for many Warrington women it was the end of a hard-fought campaign. Others saw it as just the start of the continuing battle for equality for women in all areas of society. By 1918 the eldest Broadbent sister, Constance Harvey Broadbent (1864–1943), had already become an important figure in Warrington life. Besides joining

her sisters' war work she had become a member of the Board of Guardians in 1904, was much involved in Warrington Workhouse and served as a Justice of the Peace.

In the 1918 elections she stood as a Conservative candidate for Latchford ward as one of the first Warrington women to seek political office under the provisions of the 1918 Act. She won a sweeping victory against the Labour candidate, Charles Dukes. Her triumph was not merely a result of her recognised public service but because Conservatives, Liberals and women voters united against a left-wing Labour candidate who many still regarded as unpatriotic for his wartime stance as a conscientious objector.

Birkenhead-born Alison Garland became the first woman to stand as a parliamentary candidate for the Warrington constituency in 1929 in the so-called 'Flapper Election' when women aged twenty-one to twenty-nine gained the vote under the 1928 Representation of the People Act. She represented the Liberal Party in an election that was held against the background of rising unemployment. Unfortunately, she trailed as a dismal bottom of the poll in a close-fought contest between Conservative candidate Noel B. Goldie and victor Charles Dukes, whose credentials as a trade unionist made him a popular choice in an industrial town.

Edith Summerskill, elected Warrington's first female MP in 1955.

In 1955, Warrington finally elected its first female MP, prominent Labour politician Edith Summerskill. As an ardent feminist she campaigned for the legalisation of abortion and for equal pay and opportunities for women. As a child she had accompanied her father, who was also a London doctor, on home visits and later claimed that the exposure to ill health and poverty combined with his radical politics and support for women's suffrage were crucial in shaping her professional and political careers. She had married a fellow doctor but kept her own surname and described parliament as 'like a boys' school which had decided to take a few girls'.

She was an early member of the Socialist Medical Association and throughout the 1930s and '40s had campaigned within the Labour Party for a free National Health Service. As Warrington's MP she campaigned to improve the town's poor air quality caused by industrial pollution. She served as a minister in Clement Attlee's post-war Labour government, was a member of the Labour Party's National Executive Committee and served as Labour Party chair (1954–5). She left the House of Commons in 1961 and was created a life peer as Baroness Summerskill.

Meanwhile, in 1954 Mary Hardman became Warrington's first female mayor, rather than serving in the supporting role as mayoress. Although the corridors of the town hall were still dominated by portraits of her male predecessors, the council chamber and committee rooms were soon filled with many women councillors and other women took on the role of the town's first citizen. However, even by the early twenty-first century Warrington's women had yet to achieve equal status in all walks of life.

6. Secret Societies

Many Warringtonians have belonged to organisations which outsiders may regard as 'secret societies' because only the members fully understand their aims, their rituals or had taken an oath of loyalty on joining the society. However, rather than hiding behind a wall of secrecy the origins of these groups have often merely been forgotten through time.

From the early nineteenth century, many of the town's ordinary working men were members of so-called Friendly Societies like The Ancient Order of Foresters or The Loyal Order of Ancient Shepherds even though they were employed in the local wireworks or other factories rather than in agriculture.

Until 1824 membership of trade unions was illegal and even in the early twentieth century some employers had yet to recognise trade unions. Workers had formed local trade clubs which met socially in pubs whose names survived as The Brickmakers' or Glassmakers' Arms. However, workmen still had few rights in law; wages were low and before the days of the welfare state sickness or unemployment meant disaster for their families. To counter this, from the 1820s, Friendly Societies were established as

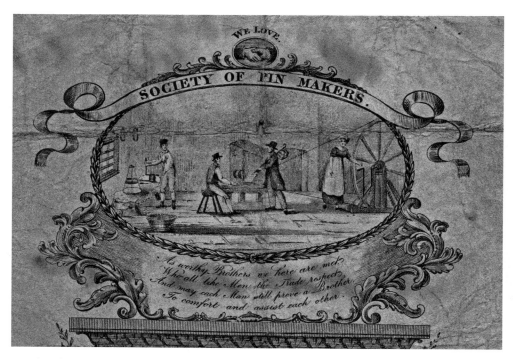

Membership card for the Society of Pin Makers.

not-for-profit organisations which existed for the mutual benefit of their members who would receive sick pay or funeral grants in return for their modest weekly subscriptions.

However, while the working man socialised in his local pub there was a danger that what little cash he had might be spent on beer rather than supporting his family, and potentially lead to domestic violence when he staggered home drunk. 'If I could destroy tomorrow the desire for strong drink in the people of England, what changes we would see,' proclaimed leading politician Joseph Chamberlain. However, the powerful brewing firms in towns like Warrington would fiercely oppose the sentiment.

Brewing was already established in Warrington by the late eighteenth century and the town's love of beer even made it into a Georgian ballad called 'Warrington Ale!' By the end of the nineteenth century Warrington was known as a major brewing centre through Greenall's, Walkers, and the Burtonwood brewery especially. What is less well known is Warrington's important role in the opposition to intoxicating drinks.

The idea of temperance movements (groups who agreed not to drink strong alcohol or to drink only in moderation) had its origins in America in the early 1800s. However, it was in Ireland that the idea of abstaining entirely from all alcoholic drinks began to emerge. The well-known Dublin Quaker and vegetarian George Harrison Birkett took up this cause with a passion. In March 1830, he travelled to Warrington to promote his cause, perhaps encouraged by the already existing presence of a strong temperance movement in the town.

Greenall's Wilderspool Brewery.

Burtonwood Ales
had introduced
bottled ale in
the 1890s.

At first Birkett did not receive a strong welcome, finding it difficult to locate anyone who would even rent him a room to hold his meetings. Eventually, Thomas Eaton, a manager on the Bridgewater Canal and member of the Independent Methodists, allowed him use of Providence Chapel on Chapel Lane, Stockton Heath. Following the first meeting at the chapel on 4 April 1830, the country's very first Total Abstinence Society was formed and after five weeks at Warrington, Birkett moved on to spread his message to the people of Manchester.

By June a second branch had been formed, meeting at Friar's Green Chapel in Warrington, but this branch did not fare quite so well, with half of its members reverting back to the more moderate principles of temperance after only a few meetings. Following that first meeting at Stockton Heath members were encouraged to 'sign the pledge'. This meant signing a public document agreeing to the principles of total abstinence, a principle that still continues to this day.

A battered family shows the evils of drink in a Rechabite parade.

In 1910, the Warrington branch of the Independent Order of Rechabites celebrated its seventy-fifth anniversary with a parade of floats through the town centre depicting the evils of drink. This Friendly Society insisted that all its members signed the pledge and at a public meeting at the Parr Hall one speaker claimed that, 'Through the agencies of day schools, bands of hope and juvenile tents, there was arising a generation which was learning the physical as well as moral damage which the use of alcohol entailed.'

The Band of Hope had been active in eight of the town's Sunday schools since the mid-1850s and soon hundreds of children were enrolled and took the pledge. To attract more young people to the movement an annual Warrington Band of Hope festival began in 1903 and was later staged at the Parr Hall. A large cast featured the Queen and her retinue, including characters named after spring flowers, the virtues, nursery rhyme characters and historic and legendary figures. The rehearsals and opportunity to perform on stage to a large local audience became the highlight of the year for the young participants.

However, although the temperance movement continued to attract support in the town's nonconformist chapels the attractions of pub sports teams and coach outings in the 1920s proved more attractive to the general population, especially since many also worked in the local breweries.

The Freemasons have long been regarded as the world's largest secret society, tracing their origins back to the Middle Ages in Europe when skilled stonemasons and other craftsmen organised themselves into local guilds. They identified themselves to each other by signs of their trades, including the square and compass. They were devoted to fellowship and mutual assistance and many of their rituals were reserved for their membership, including a special handshake.

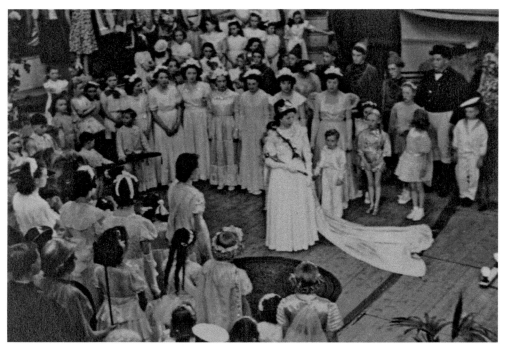

A Band of Hope pageant at the Parr Hall.

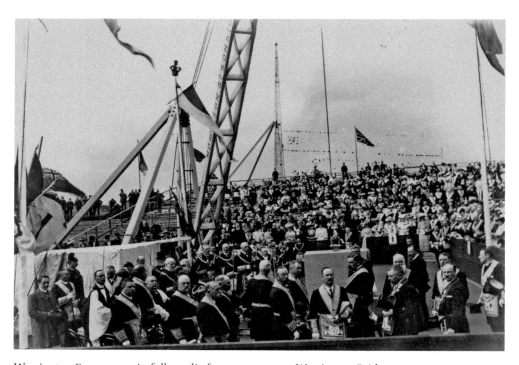

Warrington Freemasons in full regalia for a ceremony at Warrington Bridge, 1911.

Warrington has a long history with Freemasonry and in 1646 Elias Ashmole recorded that he was initiated into the movement here. Warrington's oldest Masonic group, the Lodge of Lights No. 148, has been in existence since 1765, but until the 1930s Warrington's masons had no permanent home, meeting instead in local inns.

On 22 September 1932, the foundation stone of their new temple in Winmarleigh Street was laid in the presence of Masonic dignitaries and prominent local businessmen. Its designer was local architect and freemason Albert Warburton, already well known as the architect of Crosfield's offices and the former Sankey Street Co-operative store. His Masonic Hall was a much plainer building, heavily influenced by the Egyptian and Greek motifs favoured by the contemporary art deco style. The simple brick façade has a striking stone entrance with two free-standing columns topped by net-covered globes, one terrestrial and the other celestial. The two columns represent the two pillars of masonry, called Jachin and Boaz, which flanked the entrance to Solomon's temple. The stone decoration features biblical and Masonic symbolism which would be clearly understood by all masons and clearly announced their presence in the town.

Prior to the mid-1930s Masonic meetings were widely reported in the local press. With the rise of Fascism and Communism in Europe Freemasons and Freemasonry became a target as their principles of religious tolerance, constitutional government, civic responsibility, meritocracy, education of the masses, and charity were seen as counter to the ideologies of dictatorships. When the Channel Islands fell to the Nazis in June 1940, the Masonic halls were looted, and many members were deported to concentration camps in mainland Europe. To protect the brethren from the repercussions if the Germans

The Masonic Hall in Winmarleigh Street designed by Albert Warburton.

did indeed invade Great Britain, the decision was taken for the organisation to become less open.

However, even after the end of the Second World War the United Grand Lodge of England continued with the policy of being a closed organisation, understandably leading to many rumours and much conjecture about the purpose of Freemasonry and what the members do. More recently, the organisation has become much more open, promoting itself as one of the largest charities in England and Wales with the membership giving millions of pounds each year to other charities, including medical research, hospices and the Air Ambulance service.

The Masonic Hall has been rebranded as Winmarleigh House, but while the ground-floor function rooms are widely visited by the local community the two imposing windowless temples on the first floor are normally reserved for members, apart from public guided tours. Around the walls are the names of the members of the various lodges, featuring many prominent local businessmen and politicians, including Sir Gilbert Greenall. The newly established Warrington Museum of Freemasonry now celebrates Masonic history in the town and its members' contribution to the local community to remove the perception of a secret organisation.

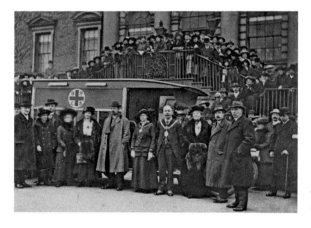

The Freemasons present an ambulance to the Red Cross in February 1917.

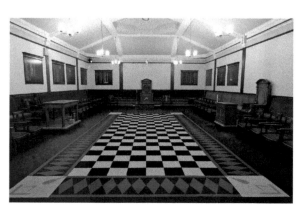

Inside the larger temple at the Masonic Hall.

7. Scandals and Outrages

For most of Warrington's history LGBT people would have lived a life of secrecy. To do otherwise would have risked persecution and even death. For this reason, stories of LGBT lives are rare to find in the town's history books and where they do appear, they often relate to a tale of great sadness. One such story is that of Isaac Hitchen and his Great Sankey Molly House.

In May 1806, Warrington Magistrates Gwillym and Borron called upon the Warrington Volunteers (an equivalent of the Territorial Army) to raid a well-established Molly House at Great Sankey. The subsequent events were reported all over the UK and became a topic of debate in pubs and coffee houses the country over. The *Newcastle Courant* reported that, 'A discovery has lately been made in Warrington, and its vicinity, sufficient to freeze the bosom of humanity with horror.'

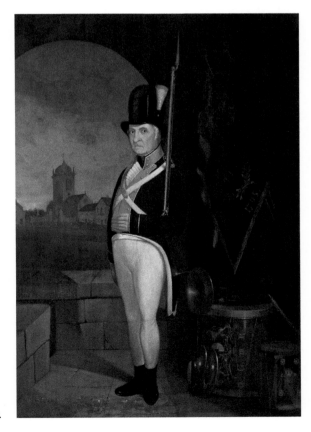

Sergeant Ashton of the Warrington Volunteers stands ready to do his duty.

Molly was a slur used to describe homosexual men in Georgian Britain, and a Molly House was the nickname given to the place where such men met to socialise. The Molly House at Great Sankey was being run by Isaac Hitchen out of rooms at an unnamed public house near Sankey Chapel. The Molly House's clientele was made up of men from all different classes of society from Warrington and the surrounding area.

The early 1800s had seen a drive by local government across the country to close down such houses with Warrington's magistrates being a part of that wider drive. In the early 1800s, homosexuality was a criminal offence punishable in various ways from time in the stocks to transportation, imprisonment, or ultimately execution depending upon the evidence presented at the trial. With this in mind, the raid at Sankey was a matter of life and death for the men arrested.

During the raid at Sankey twenty-four men from Warrington and Manchester were apprehended along with three from Liverpool, although only nine reached trial and of these nine men five would face the death penalty. Those arrested varied from wealthy businessmen to servants and labourers and ranged in age from seventeen to eighty-four.

Beyond the twenty-four men actually arrested, a large number of MPs, clergymen and members of the local gentry were investigated by the magistrates, but avoided arrest. This part of the investigation caused considerable unrest amongst the gentry of Cheshire

Near Hitchen's Molly House at Great Sankey in the 1830s.

and Lancashire, who saw their authority as being threatened. Such was the upset caused that Sir Robert Graham, the judge conducting the trial into the five men facing the death penalty, informed Gwillym and Borron that when it came to people of their own class their 'first duty was silence'. Following censure from the judge, their colleagues, the Home Office, and Lord Ellenborough the Lord Chief Justice, the Warrington Magistrates stated publicly that they had only been investigating 'higher standing' men to prove their innocence in the face of gossip.

This reprieve for the authority figures connected to the Molly House did not unfortunately extend to the lower or middle classes. In September of 1806, five of the men arrested at the Molly House were sentenced to death. On 13 September, John Powell, a publican from Great Sankey, Joseph Holland, a pawnbroker from Warrington, and Samuel Stockton, whose job is not recorded, were executed at Hanging Corner in Lancaster Castle. They were convicted largely due to the evidence given by John Knight, a wealthy gentleman arrested along with them who turned King's evidence in order to save his own life. The *Lancashire Gazette* reported that Stockton 'appeared much agitated, his trembling limbs appeared almost inadequate to their task'; that Powell 'did not show as much dejection'; and that Holland 'appeared in a state of the greatest agitation' and appeared to 'implore the pardon of mighty God with greatest fervency'. Descriptions of hangings sold many newspapers and journalists would often embellish the descriptions to suit their readers' expectations.

Isaac Hitchen himself, along with Thomas Rix, described as an artisan chair-bottomer from Manchester, were given two weeks longer to live in the hopes that one of them could be induced to confess the names of other men associated with the Molly House. It was common practice at the time to reduce the severity of a prisoner's sentence if they would provide damning evidence against their fellow prisoners. Thomas Rix, perhaps hoping to save his life, gave the magistrates the names of 'numerous and respectable' men. In a letter to Earl Spencer, Borron stated that he intended to 'make a sweep in one night of all these wretches' and 'search this sink of iniquity to the bottom'. As we learnt earlier however, the names of these respectable gentlemen were never to come under investigation. Unfortunately for Rix, despite the information he provided his death sentence was upheld.

In contrast to Rix, Hitchen protected his one-time customers, refusing to give the names or details of any of his customers to his interrogators, even if it should save his life. When questioned again by Borron, Hitchen is recorded as replying with great calmness, 'it was all French to him', and that 'he knew no more about it than the dead'.

Two weeks later, on 27 September, both Rix and Hitchen went to their deaths at Hanging Corner as their friends had done before them. Magistrates Borron and Gwillym gave up their pursuit of any further suspects and the sad events surrounding Isaac Hitchen's Molly House came to an end.

The events surrounding Isaac Hitchen's Molly House appeared in newspapers all over the country, and yet within a short time the lives of the men involved were largely forgotten, swept under the carpet as an embarrassing episode in the town's history. For many generations after these events society continued to see LGBT lives as something to be hidden away and not talked about. For this reason the story of the Molly House did not

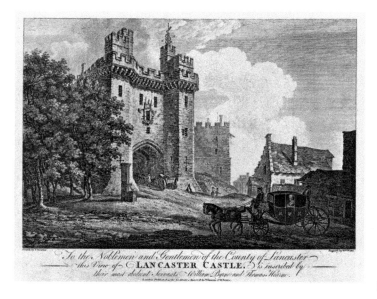

Lancaster Castle, where those condemned at the Molly House trial were hanged.

appear in any written histories of the town and became a secret and forgotten history. In recent years LGBT history has become much more accepted and Hitchin's Molly House now forms an important part of Warrington's vibrant and varied story.

Warrington's great and good may have escaped public shaming in the Molly House trials but in 1868 Dr James Kendrick had no hesitation in naming the local MPs, clergymen and leading citizens he felt were responsible for the scandalous mismanagement of the Blue Coat School and the treatment of its vulnerable pupils.

The school had been established in 1711 to provide apprenticeships for around twenty-five poor local boys. By 1820, at its new Winwick Street site 120 boys and thirty girls attended as day scholars as well as twenty-four boy boarders. A government inspection in 1858 had rated the school highly but in 1866 the school's honorary medical examiner, Dr James Kendrick, resigned in protest at the scandalous treatment of the children he had uncovered. However, the chairman of the trustees, John Ireland Blackburne, indignantly refuted his claims and defended the school's head, Mr Bowes by writing:

Having themselves gone as fully as possible into the charges, the Trustees are unanimous in declaring that nothing has been proved to justify the attacks which have been made upon the institution, and that they find nothing whatever in the management of it which calls for any alteration.

Dr James Kendrick who exposed
the Blue Coat scandal.

Kendrick felt that his criticisms had been politicised and misrepresented as an attack by him on the largely Tory trustees and that his professional reputation was in question. In 1868 he published his damning findings in a pamphlet called *The Warrington Blue-Coat Exposure and its Beneficial Results*, including detailed and harrowing evidence supplied by parents and some of the scholars themselves and illustrating horrific failures to safeguard the young and vulnerable children.

Kendrick was supported by Mr Hardy, a senior local practitioner for fifty years who noted the beneficial effects of Kendrick's intervention and outlined the pupils' sufferings:

> Your justification is as complete as it can be. The Trustees have virtually acknowledged the truthfulness of the complaints you made against the management of the institution by immediately correcting the abuses you specified. The children are now better fed-they are now supplied with knives and forks, and are not required to take their food with their fingers like so many monkeys; more attention is paid to the proper cleansing of their bodies; their bed-lined is now more frequently changed; they are not now wearing out their stockings without having been either washed or mended; and there is to be no more floggings by militia sergeants.

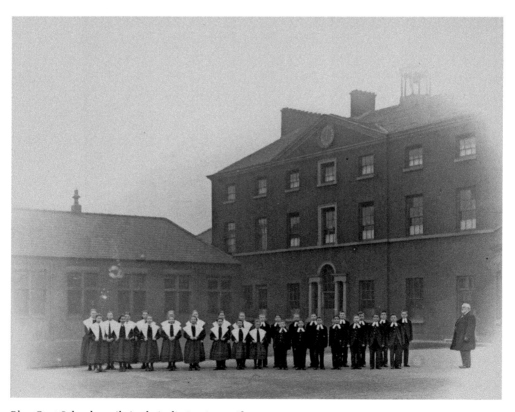

Blue Coat School pupils in their distinctive uniforms.

The Blue Coat School survived and regained public support over time, which allowed it to continue in the town until it relocated to Preston Brook in 1922, but at the time the incident had shaken confidence in the actions of leading public figures and revealed the apparent hypocrisy of those clergy who had failed to show true Christian charity towards their charges.

In 1943, Warrington found itself at the centre of another scandal which attracted nationwide press coverage and was even raised in Parliament. By the end of 1942, the town had welcomed American GIs from the Burtonwood United States Army Air Force (USAAF) base as their allies in the Second World War against the fascist government of Adolph Hitler and his Axis allies. Hitler's Nazi followers had embraced an ideology which identified German Aryans as a pure 'master race' which had to be protected from inferior races and especially the Jewish race. The Nazis' subsequent persecution of the Jews was a major factor in the decision of Britain and later her ally the United States to go to war with Hitler and the Axis armies. However, Warrington soon found itself at odds with the Americans of Burtonwood over their own version of racism with the Jewish manager of a local dance hall as a catalyst.

The Casino Club had opened at Market Gate in December 1938, decorated in the popular art deco style of ivory and black with a series of murals featuring Duke Ellington and other jazz celebrities. The manager, Nat Bookbinder, was a Jewish jazz musician who, with his dance band, The Six Chapters, set out to popularise jazz and Blues music and introduced special 'Harlem Nights' in tribute to leading African American musicians. Warringtonians flocked to dance at the Casino Club, while Bookbinder helped develop the career of local musicians, including artists of colour. By 1942, the Casino Club was the most popular club in town and the Market Gate area with the nearby Pelican Inn and the Empire Cinema and Billiard Hall the focus for a night out in Warrington.

The base commander of Burtonwood and Warrington's mayor formalise the wartime alliance.

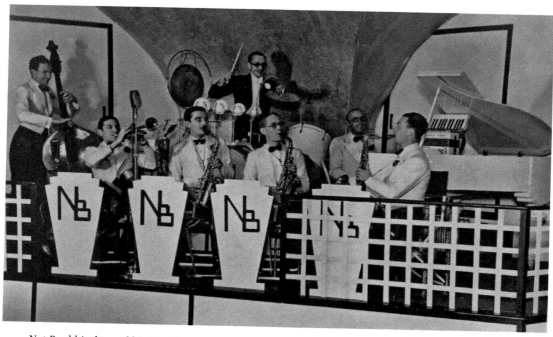

Nat Bookbinder and his Six Chapters.

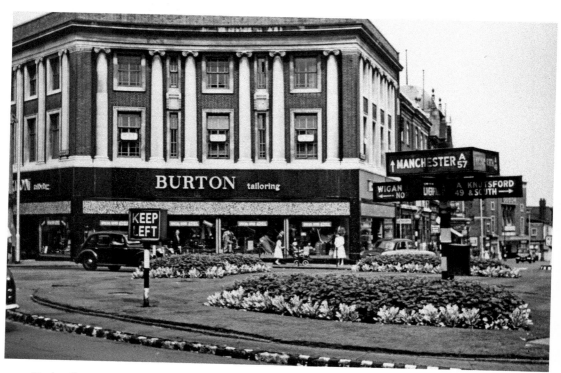

Market Gate wartime nightlife centred on the Casino Club above Burtons.

At first the Americans embraced the opportunity to chat up the local girls, show off their jitterbugging skills on the dance floor and sink a few pints, but soon the atmosphere changed as Warringtonians discovered that the USAAF had a different culture to their hosts. American service personnel in Britain followed the same policy of racial segregation which was in operation in America, a system known as 'The Colour Bar', a legacy of the days of slavery. African Americans did not enjoy the same status as white Americans and on the base the black and white soldiers lived in separate billets, ate in separate canteens, did not socialise and the black American GIs were paid less.

The British government recognised that this segregation was a potential point of conflict with West Indians, Africans and other workers from the British Empire who had come to Britain to fight or take on war work. They reached an uneasy compromise with their US allies by allowing them to continue segregation at their bases, but this would not be enforced in the wider community. At first there was an uneasy truce in Warrington but the local girls soon realised that the white GIs disapproved of them socialising with their black counterparts.

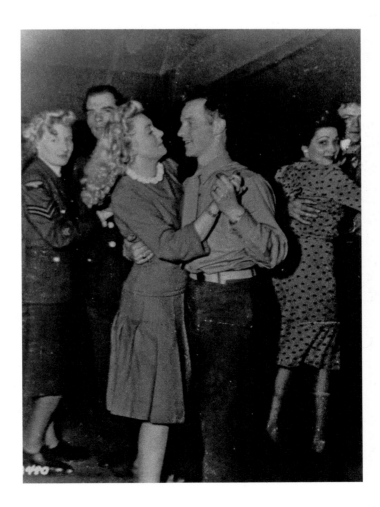

Dancing the night away with a GI.

The flashpoint came unexpectedly one night when a group of white GIs demanded that Bookbinder should evict regular customer Herbert Greaves, a 'quiet and diffident' twenty-three-year-old Jamaican technician. Bookbinder refused but Greaves left in distress and the incident soon escalated. Captain Laing from the Burtonwood base wrote to Bookbinder threatening to put the Casino Club out of bounds to all US personnel if people of colour were admitted. Bookbinder refused to comply stating that he would rather 'Place the ballroom out of bounds to white Americans rather than forbid the attendance of coloured British subjects.'

The American authorities promptly carried out their threat. Bookbinder's takings fell, especially when all British military personnel were suddenly banned as well with the excuse that this was for safety reasons because the venue was often overcrowded. Many Warringtonians felt that this was merely a cover-up to avoid upsetting Britain's ally. Warrington's MP, Noel Goldie, raised the issue in Parliament but failed to get a satisfactory response from the War Office.

By December 1943, the club's income had fallen by 90 per cent and any British servicemen trying to ignore the ban were swiftly ejected by the British Military Police. Meanwhile, either by coincidence or part of the attempt to cover up the incident, Nat Bookbinder was called up to serve in the army and the Casino Club soon closed. Sadly, Bookbinder found it difficult to continue his music career after the war and with Greaves became a victim of a war that had been waged partly to counter racism.

8. Warrington and the Wider World

Until the twentieth century few Warringtonians travelled outside their home town, but one notable exception was Thomas Dallam. In 1599–1600, at the age of twenty-nine, he made a six-month voyage to Constantinople (Istanbul) to deliver a mechanical organ-clock he had built to Sultan Murat II, leader of the powerful Ottoman (Turkish) Empire. The organ was commissioned by Queen Elizabeth I as a unique gift to persuade the sultan to allow English merchants to cross his empire and open up lucrative trade routes to India and other eastern countries.

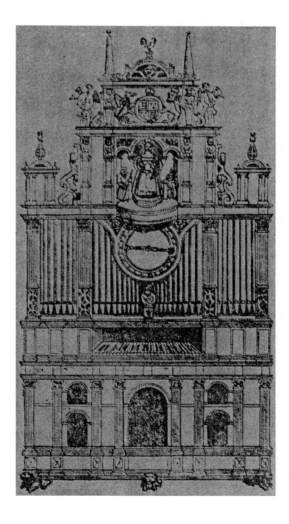

Thomas Dallam's organ presented to
Sultan Murat III.

Dallam personally demonstrated his magnificent 12-foot-high mechanical organ which not only played a variety of tunes and instruments but also delighted the sultan as an entertaining clock. Dallam returned home in triumph and his family became one of England's premier organ-builders. England gained the desired trade routes and a long-standing alliance with the Turkish Empire.

Two centuries later Warrington merchants had also begun international trade. While the town's growing prosperity has long been recognised by historians until recently, the darker side to the source of this wealth has been less widely known. John Blackburne and Thomas Patten were two of Warrington's most important businessmen in the mid-eighteenth century. Both grew wealthy from what they would regard as 'a very respectable trade' but which is acknowledged today as slavery, even if they were not directly involved in human trafficking.

Patten's copper works produced copper bangles (called manillas) which others traded in Africa for slaves. These slaves were then sent to England's colonies in the West Indies where they worked on the sugar plantations. Here too Patten had an interest, for his works produced large copper pans which were used to boil sugar and distil rum. The family also had an interest in a sugar works in Warrington. The Blackburne family traded in salt, which was an important currency for buying Africans. John Blackburne's son invested in Salt House Dock at Liverpool, a major port for slavery.

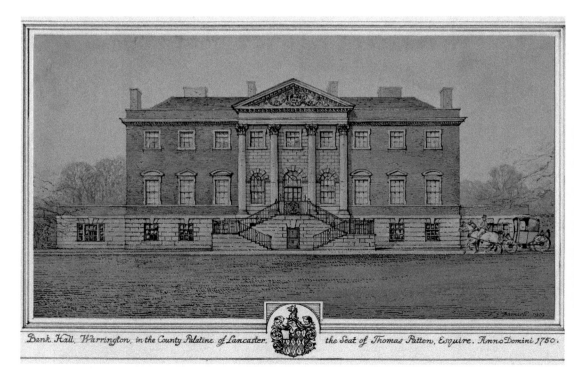

Bank Hall, Warrington, in the County Palatine of Lancaster. the Seat of Thomas Patten, Esquire. Anno Domini 1750.

Thomas Patten's Bank Hall, now Warrington Town Hall.

DID YOU KNOW
The first pineapple in the north-west of England was grown in Orford? John Blackburne was responsible for the creation of Orford Hall's gardens. He built a glasshouse which enabled him to cultivate exotic plants (acquired through family interests in the slave trade), including pineapple, sugarcane and cotton.

Other eighteenth-century Warrington businessmen grew wealthy from slavery, including Thomas Lyon and Joseph Parr who set up a bank which lent to other businesses and financed the town's growing prosperity. Meanwhile, the Pattens, Blackburnes and their associates became pillars of local society and the Anglican church.

However, many Warrington contemporaries fiercely opposed slavery, especially leading figures from the town's Nonconformist academy, Cairo Street chapel and Quaker philanthropist James Cropper. Warrington developed its own links to the abolitionist movement in America and brought anti-slavery activists to address public meetings in the town.

Martha Rylands' son, Thomas Glazebrook Rylands, was an ardent abolitionist and met with two escaped American slaves during their visits to Warrington. Moses Roper, a mixed-race slave, escaped from captivity in 1834 and fled to England, where he was helped to gain an education. He wrote one of the earliest accounts of the abuses suffered by an American slave, which shocked English society, and Rylands purchased a signed copy directly from the author.

In 1846, an equally famous writer and former slave, Frederick Douglass, stayed at Rylands' house in Bewsey Street during his tour of England. Born into a life of slavery, Douglass had escaped to freedom in Massachusetts where he published *A Narrative of the Life of Frederick Douglass, An American Slave* in 1845. Douglass acknowledged that his political thinking had been heavily influenced by reading *Dialogue between a Master and Slave* written by Anna Laetitia Barbauld and her brother, John Aikin. In 1846, Douglass gave two talks to Warrington's Mechanics' Institute and would later become a leading figure in America, fighting for African American and women's rights.

The Gaskell family and the Revd Philip Carpenter of Cairo Street chapel were also ardent abolitionists. In 1859, Carpenter was touring America to further his interest in natural history and decided to visit the southern states to gain first-hand knowledge of slavery. In St Louis he abandoned his advertised lecture in favour of abolition after being threatened by 'a committee of fifty staunch men', that he would be tarred and feathered if he delivered the speech. Carpenter returned to Warrington where he continued this and other campaigns to improve public health and was later commemorated by the erection of a drinking fountain in the town hall grounds.

Meanwhile, another Warrington abolitionist, William Robson, had met prominent African American campaigner Sara Parker Remond in Boston in 1858 and encouraged her to visit England and speak in Warrington. Her first free Warrington meeting took place at Warrington Music Hall on 24 January 1859 before a packed audience, predominantly of working people.

Revd Philip Pearsall Carpenter, a Warrington abolitionist.

On 2 February 1860, Remond was scheduled to speak on a third visit to a luncheon meeting of local women at the Lion Hotel in Bridge Street. Here she was presented with a watch inscribed, 'Presented to S.P. Remond by Englishwomen, her sisters.' Sarah responded emotionally:

> I have been received here as a sister by white women for the first time in my life. I have been removed from the degradation which overhangs all persons of my complexion; and I have felt most deeply that since I have been in Warrington and in England that I have received a sympathy I was never offered before.

Apart from achieving substantial donations for the American Anti-Slavery Society Remond's speeches also persuaded 3,522 local politicians, clergymen and ordinary citizens to sign a petition in favour of abolition, which led Robson to write that, 'No address on any subject has ever been more numerously signed in this town.'

In the twentieth century, Warrington clergymen were active overseas to help build a more equal society, including the Revd George Briggs' ministry to African churches. Here he worked closely with Father Trevor Huddleston, a leading figure in South Africa's anti-apartheid campaign. Meanwhile, the wartime Casino Club incident had demonstrated that Warrington remained opposed to America's continued separatist policies.

In January 1967, the US army returned to Burtonwood after being expelled from France by their former NATO allies. Warrington was again a hub for US international logistics. The large Header House warehouse at Burtonwood became a supply depot for the American military, holding stores to be used in the event of a further war in Europe.

In 1979, the decision was made to deploy US Cruise and Pershing missiles in Britain and several other European countries. This brought the threat of nuclear war to the front of many people's minds and made Burtonwood a focus for protest. On 7 March 1982, CND

The Burtonwood Peace Camp, 1982–3.

(the Campaign for Nuclear Disarmament) set up the Burtonwood People's Peace Camp on Sycamore Lane, Great Sankey.

The camp, consisting of a series of tents, caravans, old vehicles, and other temporary homes, was set up opposite the living quarters of the US Air Force Supply Depot at Burtonwood. The peace protestors believed that the depot at Burtonwood maintained one complete set of stores for one entire division, which they stated meant 'everything from tea bags and chewing gum to nuclear missiles'. They also believed that the site was housing 'Nuclear demolition munitions – which are nuclear mines in everyday language'.

By setting up the camp the protestors wanted to show their opposition to nuclear weapons and persuade others to see the danger they posed. In the first edition of the camp newsletter one campaigner recorded:

> We all felt so strong in ourselves. We were happy to be here, we came here for a purpose. We were all working for peace. We were happy to be alive on this wonderful planet. We don't want to see our world blown up by some ignorant people who don't know what life is about. It is up to us to tell people how senseless it is to destroy God's wonderful planet.

Local residents gathered 400 signatures calling for the camp to be removed, while camp members gathered 500 signatures calling for it to be left in place. Despite some opposition to the camp, it lasted for just over a year, closing in 1983. After that, sporadic protests still took place at the camp, like the 'Surround and decorate' protest in 1984 or the protest against the bombing of Libya in 1986.

A Warrington Campaign for Nuclear Disarmament protest, March 1982–3.

With the ending of the Cold War in 1991 the withdrawal of American troops began. The closure of Burtonwood base was announced soon after and completed in October 1993. With the end of the American military presence came the end of the Peace Camp and the many anti-war protests held at the site. Meanwhile, Warrington had been at the forefront of more peaceful space collaboration with America.

DID YOU KNOW
ESR Technology of Risley provided a crucial piece of equipment for the Hubble telescope launched in 1990 as a partnership between NASA and the European Space Agency. ESR's Solar Array Drive Mechanism enabled the maximum amount of sunlight to power the Hubble's solar cells and ultimately the telescope's instruments and batteries, capturing thousands of images of galaxies many billions of light years away.

Aubrey Rodney (right) and Egbert Gordon (left), two of British Aluminium's Warrington workers in 1960.

Early twenty-first-century Warrington was also beginning to reflect the growth of a more open and global society. The large Irish community which had settled in the town during the nineteenth century was followed from the 1950s by new residents from Britain's commonwealth countries. By the 2021 census the town had welcomed groups fleeing conflict across the world, including Hong Kong and refugees from Ukraine's war, while the LGBT community was no longer hidden from the town's history.

The new town of Warrington is gradually forging its own identity, while starting to reclaim its often hidden or forgotten past. In May 2023, the University of Chester opened its new town centre campus in Barbauld Street, close to the original Warrington Academy, naming it Sarah Parker Redmond House. Meanwhile, however, the true purpose of the ten enigmatic glass and copper figures which surround the well of light at Market Gate is still unknown to the hundreds of Warringtonians who pass them daily. Popularly known as 'The Skittles', these abstract shapes represent the Guardians of the town's past, present and future and hopefully over time their true identity, together with the many facets of Warrington's unique history, will become an open secret.

Members of the Ukraine hub take part in Croft Carnival in 2022.

The Guardians of Warrington's Past, Present and Future at Market Gate.

Further Resources

A History of Warrington by Alan Crosby (2002) Phillimore & Co.
Celebrating Warrington by Janice Hayes (2022) Amberley Publishing
The A-Z of Warrington by Janice Hayes (2019) Amberley Publishing
Warrington: From New Town to New City? by Janice Hayes (2019) Amberley Publishing
Warrington in 50 Buildings by Janice Hayes (2016) Amberley Publishing
The Archives and Local Studies collections of Warrington Museum

Acknowledgements

This book has been compiled from records and images held by Culture Warrington's Museum & Archives sections. Other images appear courtesy of the Warrington Guardian. Every effort has been made to trace copyright holders of material in this book. Acknowledgements are due to everyone who has added to our understanding of the story of our town, including Archives volunteers, and especially Carol Mayo who uncovered Amy Johnson's visit to Warrington. Thanks are also owed to Archives Assistant Lynda Rankine for help in accessing the records.